TRAVELS OF *Suki*
THE ADVENTURE CAT

MARTINA GUTFREUND

LEIGH-ANNE INGRAM

Andrews McMeel
PUBLISHING®

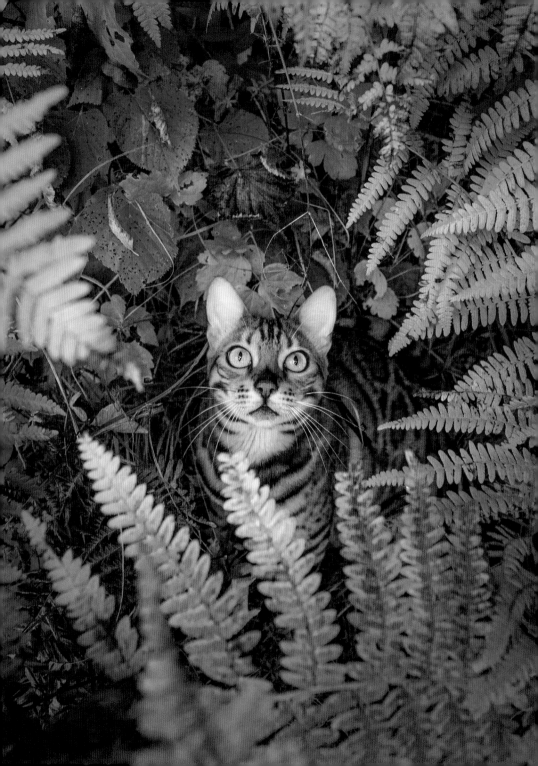

HELLO!

My name is Suki, and I'm a three-year-old Bengal cat. I live with my humans (Martina and Kenneth) in Alberta, Canada, but I've traveled all over the world. When I was three months old, my humans started taking me outside in a harness, and I quickly realized that *cat–sploring* was the life for me.

From the snowy Swiss Alps to the red rocks of Utah, I've learned that there's so much to see and sniff and savor. This world is full of adventures, and I plan to use all nine of my lives finding them. They call me Suki the Adventure Cat for a reason! *Cat–sploring* has taught me so much that I'd love to share with you.

So, take my paw, and let's go . . .

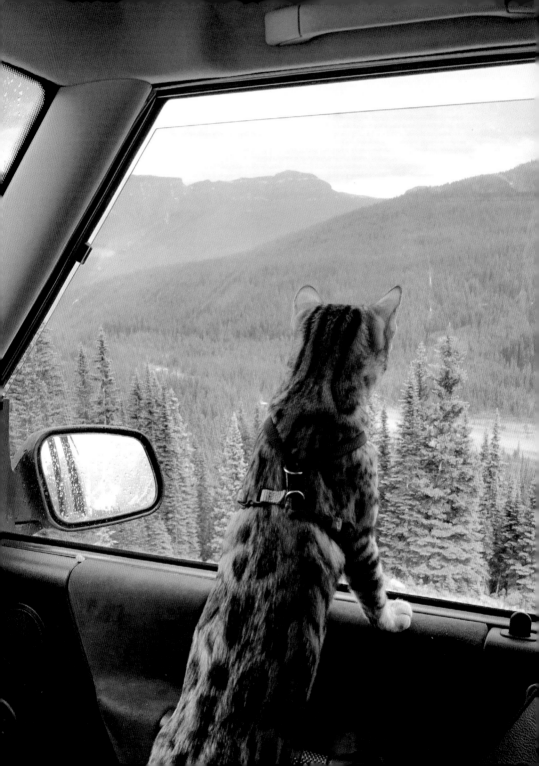

A CAT NEEDS TO LOOK BEYOND
THEIR OWN WINDOW AND GET
OUTSIDE TO TRULY SEE THEMSELVES.

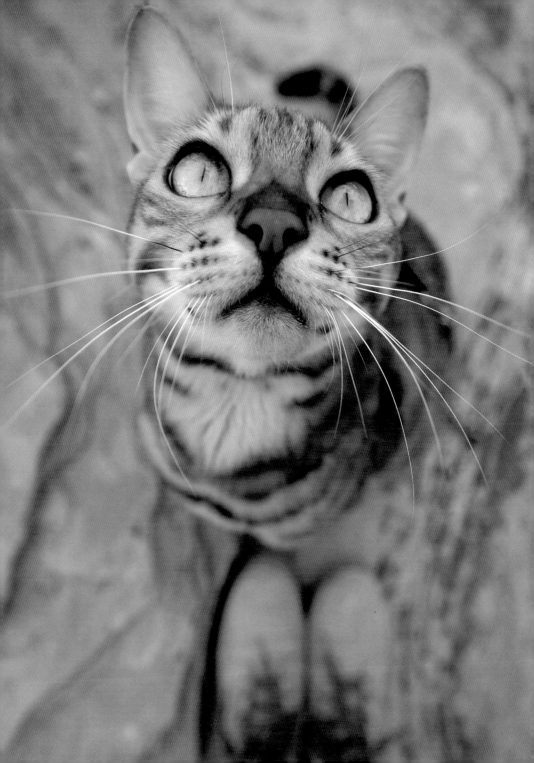

These big eyes were
made to see remarkable things;
they are the *windows*
to this *wonderful world.*

PURR-HAPS

THE BEST THING IN LIFE IS TO BLAZE YOUR OWN TRAIL.

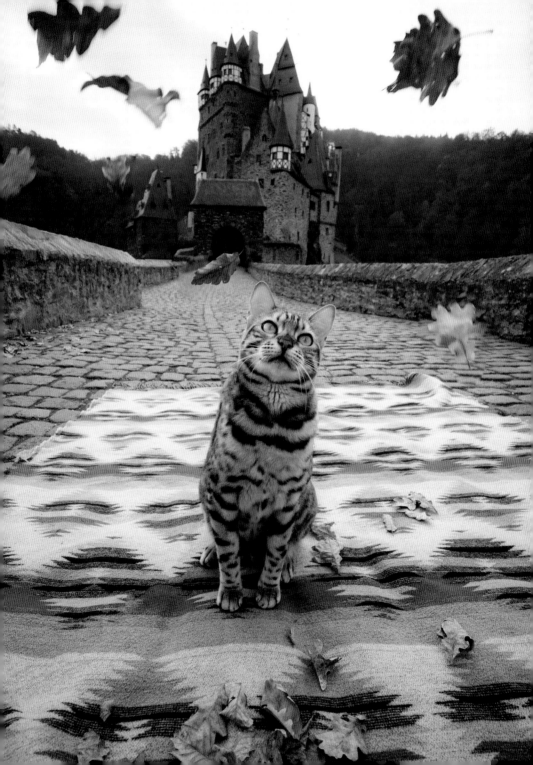

YOUR NEXT

ADVENTURE

BEGINS RIGHT AT THE

end of your bed.

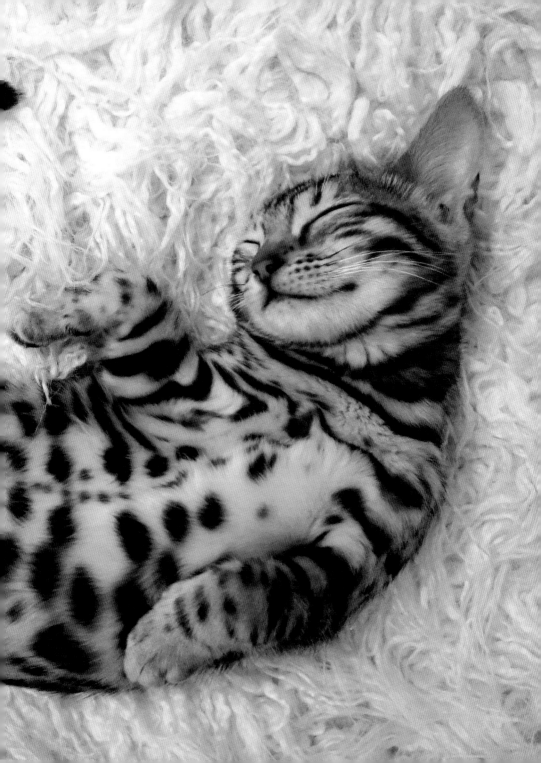

Take my paw,
AND I WILL
SHOW YOU
THE WORLD.

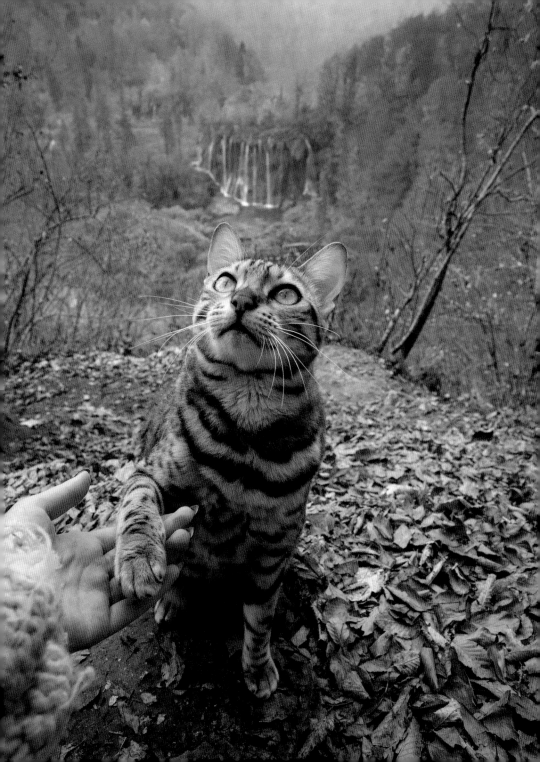

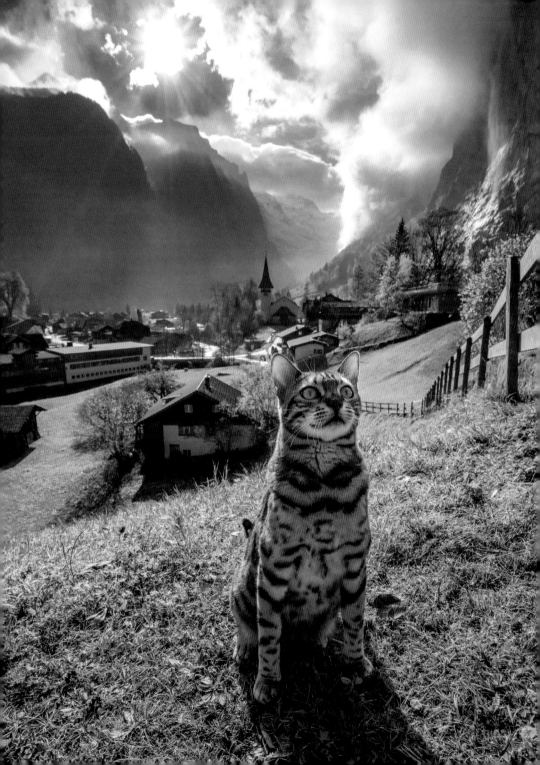

WHAT IS LIFE FOR?

To have adventures and explore!

CURIOSITY

calls the cat!

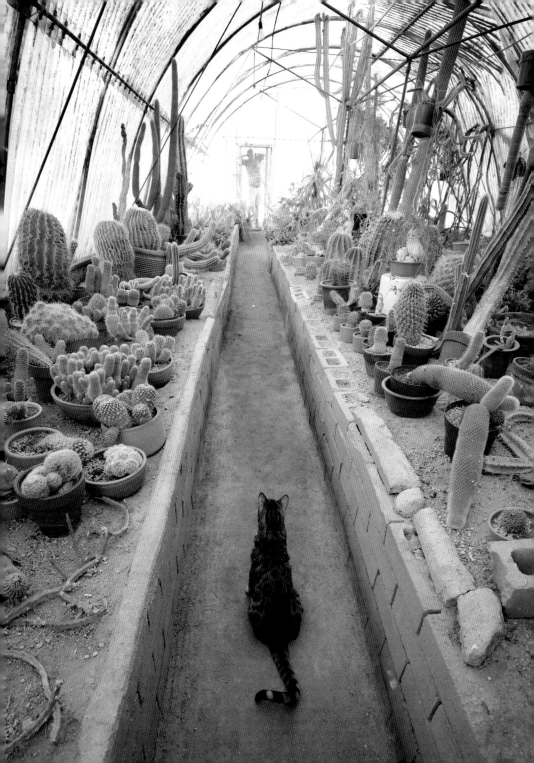

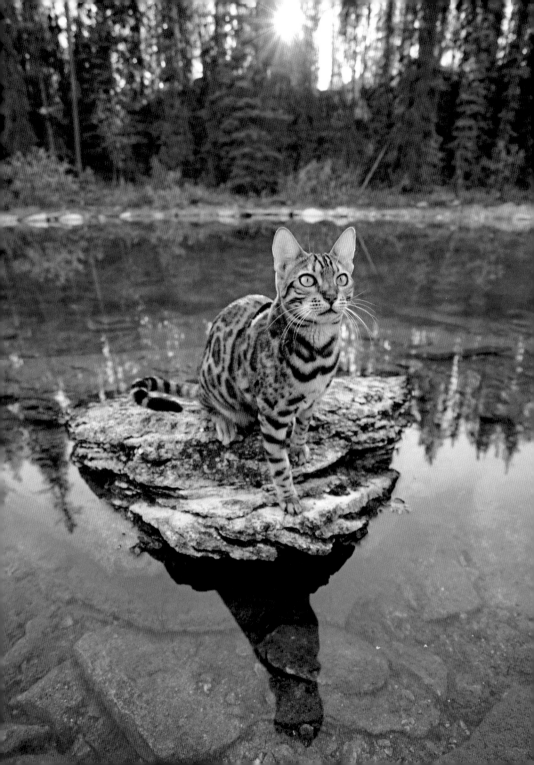

I HAVE NOT BEEN EVERYWHERE,

but it's on my list.

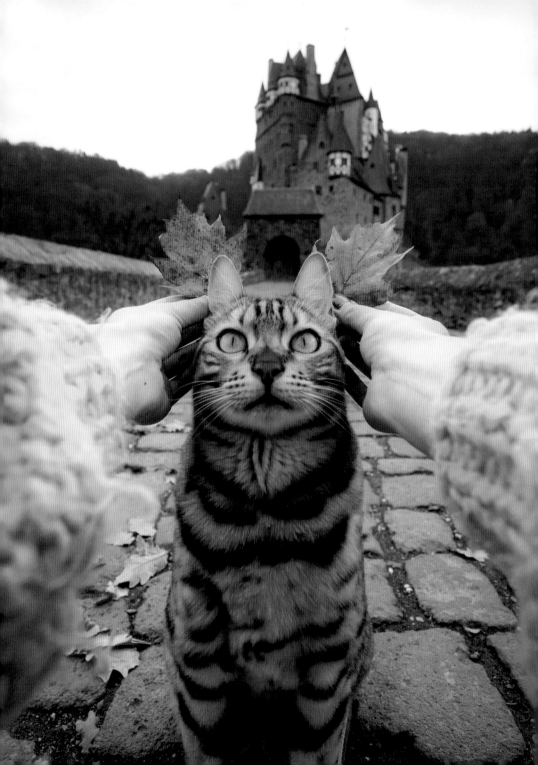

SOMETIMES YOU JUST

HAVE TO *LEAF* IT

ALL BEHIND YOU

AND GET

OUT THERE.

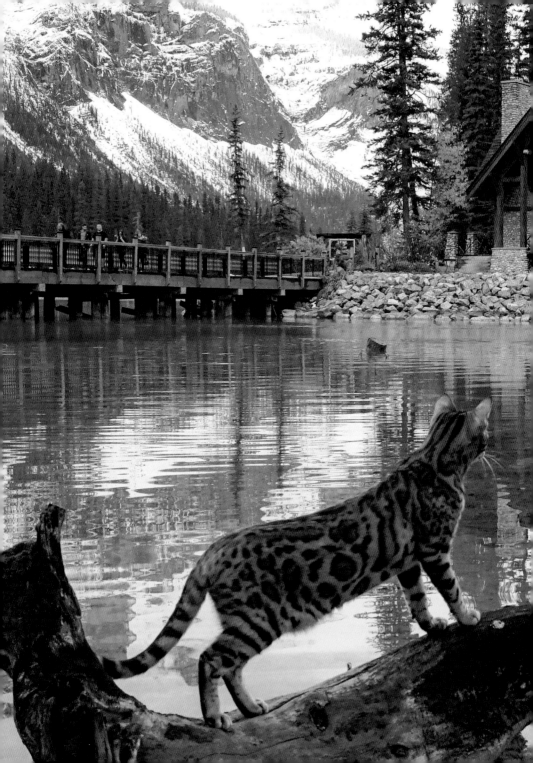

GO WHERE THE VIEWS ARE
meow-nificent!

BE TOUGH
LIKE LICHEN!

It has weathered many storms, yet
still it paints the jagged rocks of such
treacherous mountaintops.

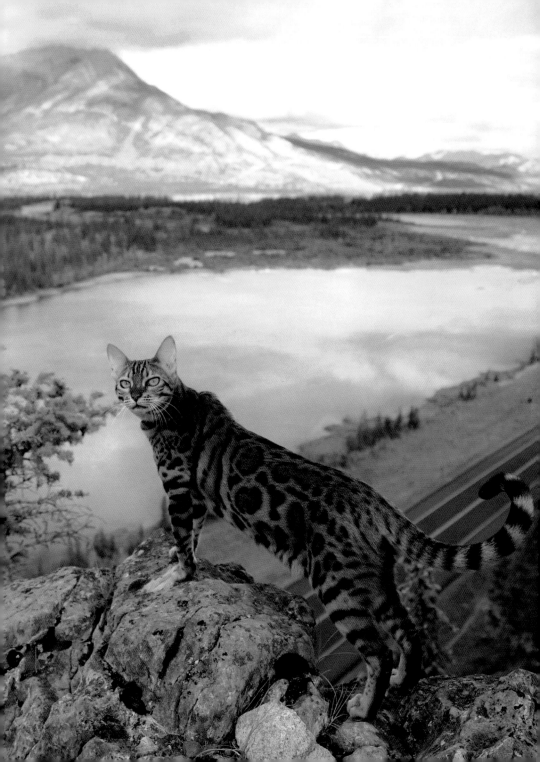

JUST CLIMB A MOUNTAIN.

It's been waiting a long time for you.

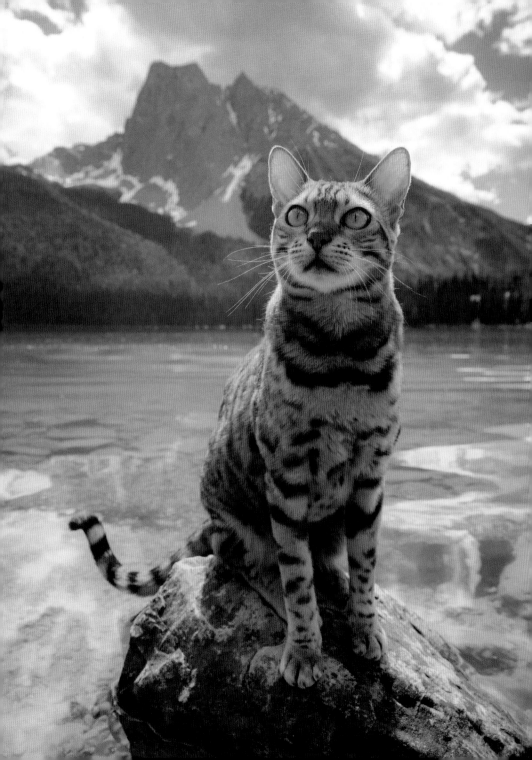

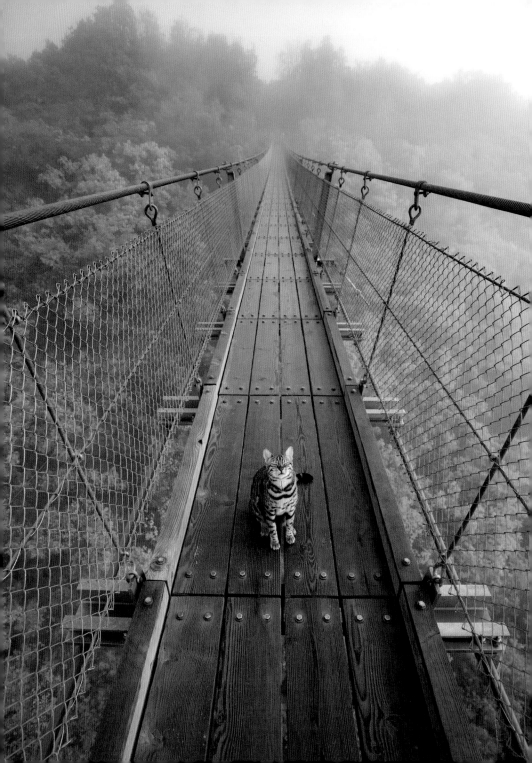

*Unleash your desire
to reach new heights.*

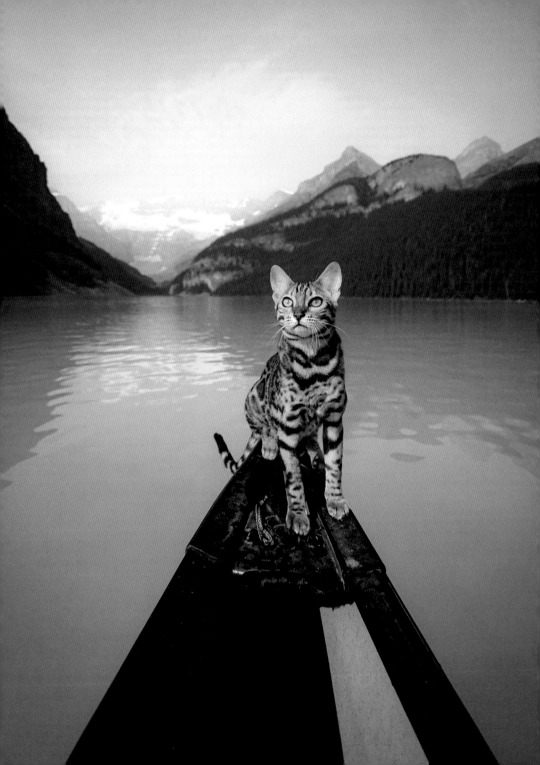

DON'T BE DISCOURAGED
WHEN YOUR LEGS GET WOBBLY;
KNOW THAT THEY TOO NEED TIME
to realize their strength.

WHAT'S UP, DOC?

ARE YOU COMING
WITH ME OR NOT?

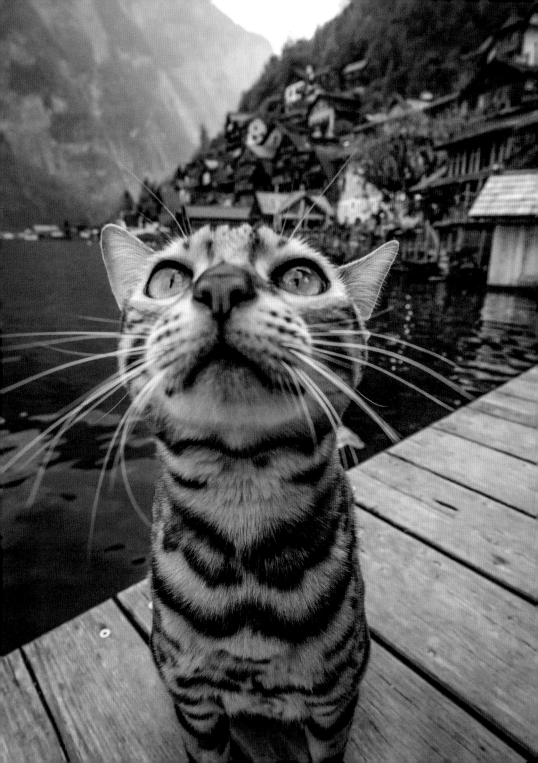

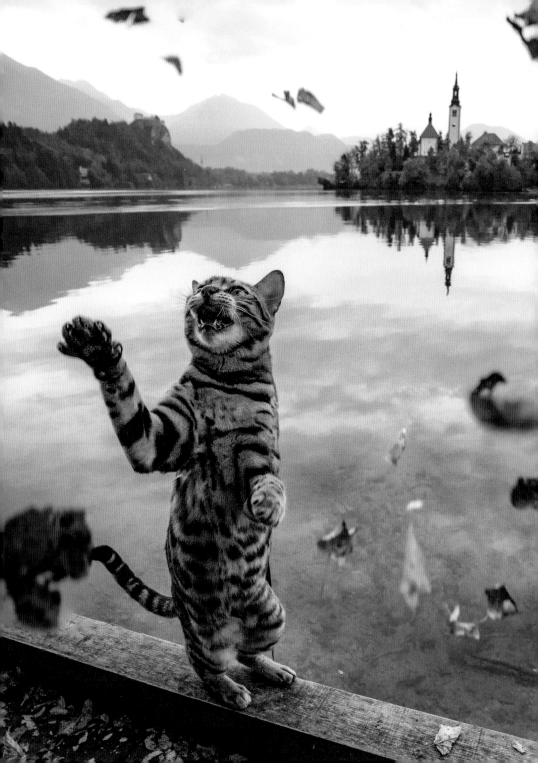

Sometimes in life,
you've got to take
a leap of faith!

Squish my cheeks,
and we'll climb those peaks!

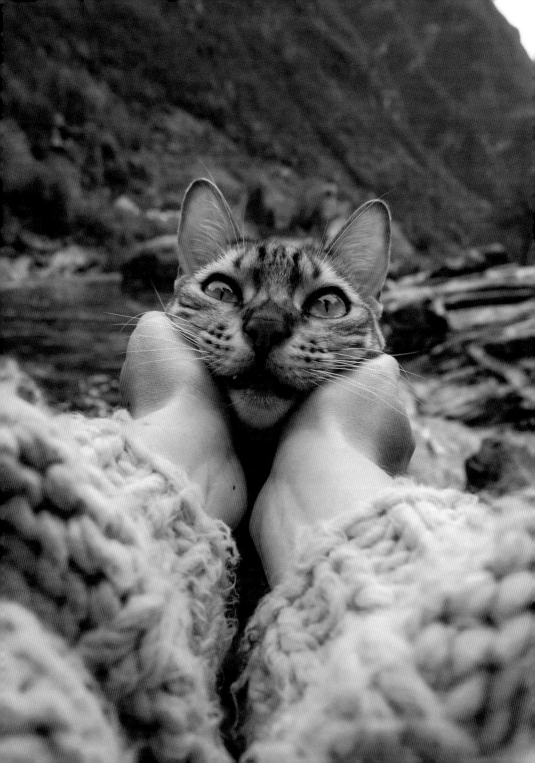

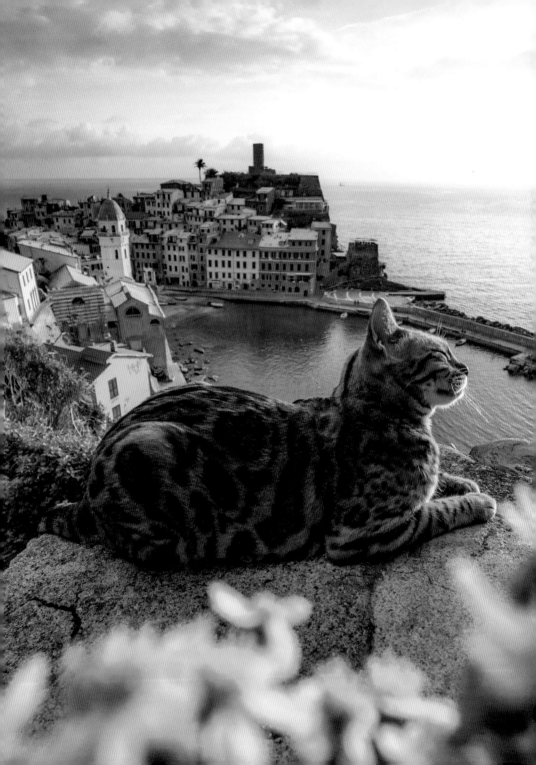

SMALL *meow-ments*
AREN'T SMALL; THEY'RE THE
MOST IMPORTANT THING
TO TRULY *enjoy* IN LIFE.

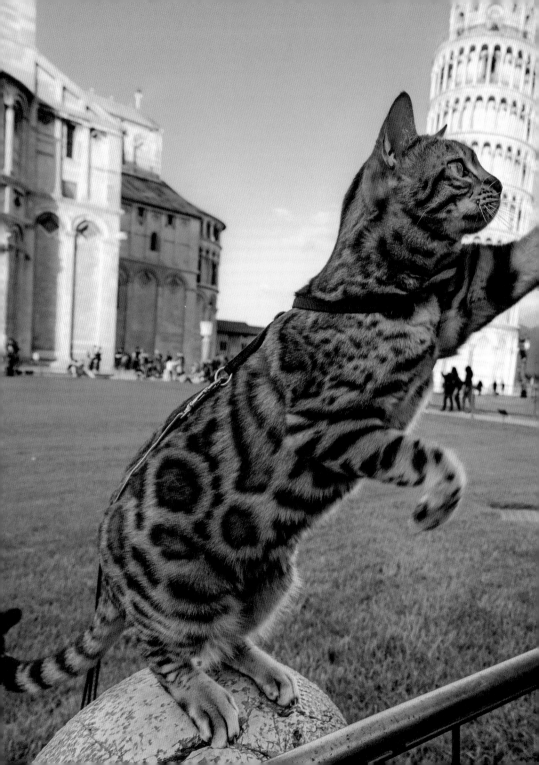

Some places are
not as easy to reach.
Let them teach you
that sometimes
the view is better
from down below.

37

THERE IS
A *meow-gical*
SUNRISE WAITING
BEYOND YOUR
BEDROOM DOOR.

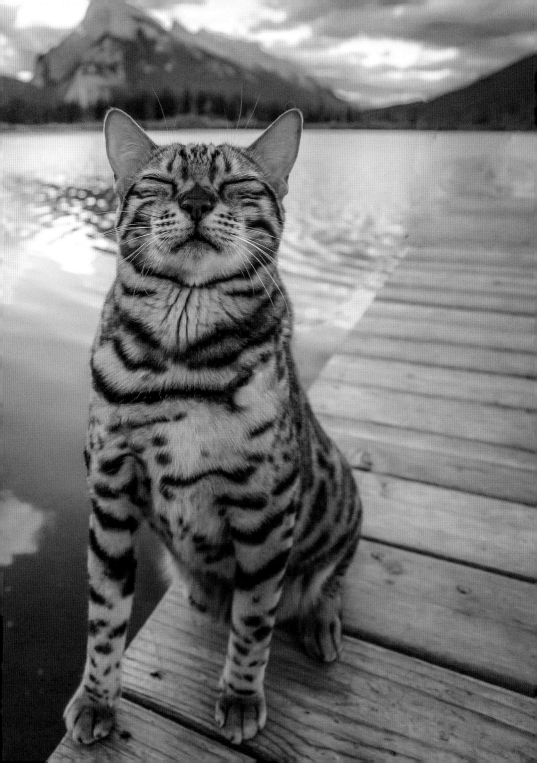

Don't be a bump on a log.
Take a deep breath when you're
feeling uncertain; even the trees
are stumped at times.

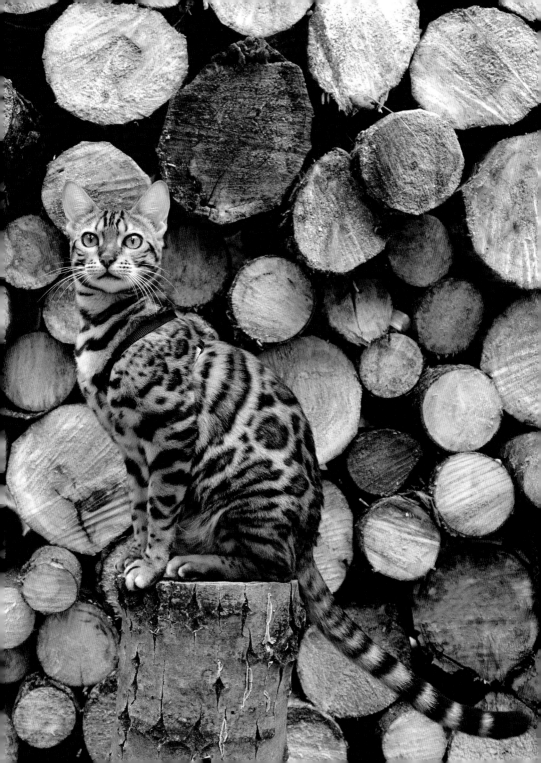

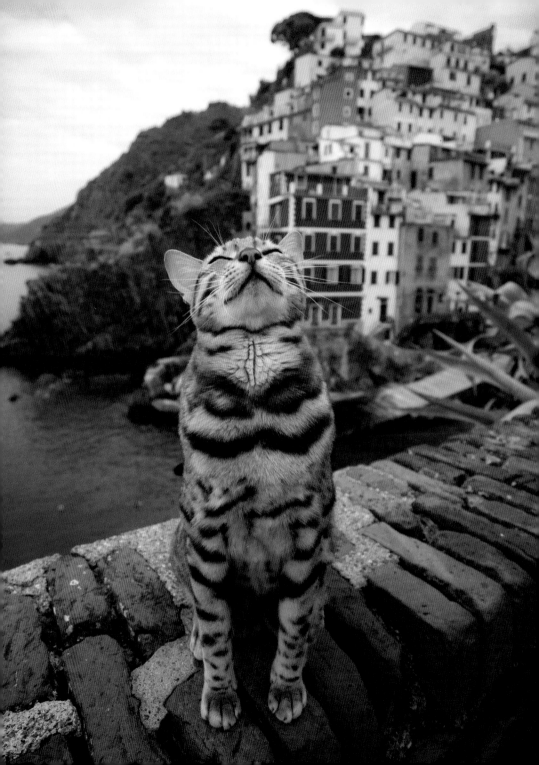

The smell of adventure—
what a marvelous thing!

PAY NO MIND
TO PRICKLES
AND THORNS,
FOR EVEN A
cactus IS FULL
OF BEAUTY
AND SPLENDOR.

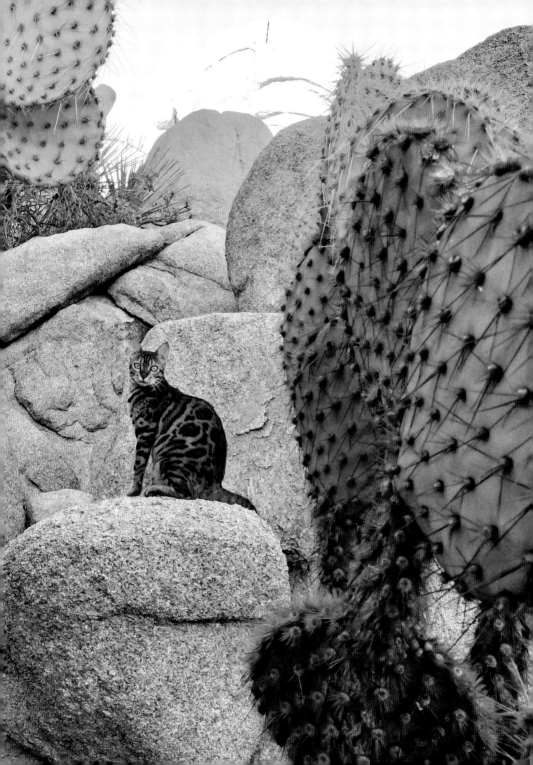

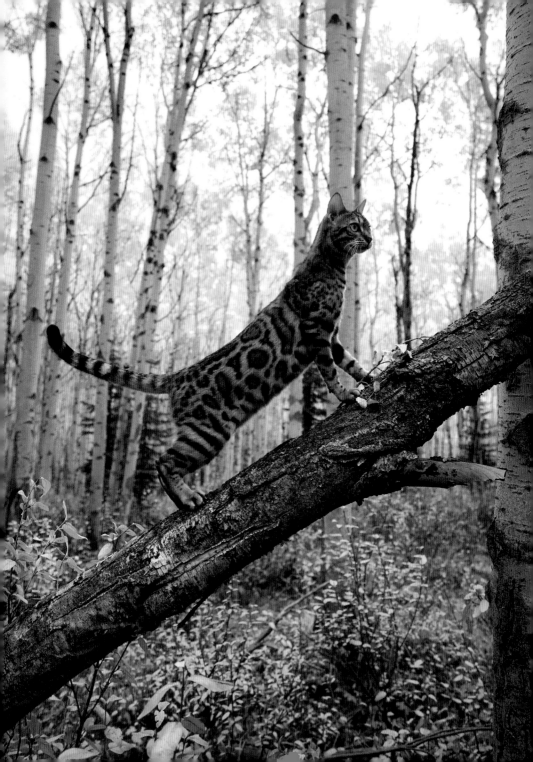

LET THE WIND
STOP YOU IN
YOUR TRACKS;
IT CARRIES
CURIOUS WHISPERS
OF THE WILD.

Some things may seem impossible . . .

until you just make the effort to do them.

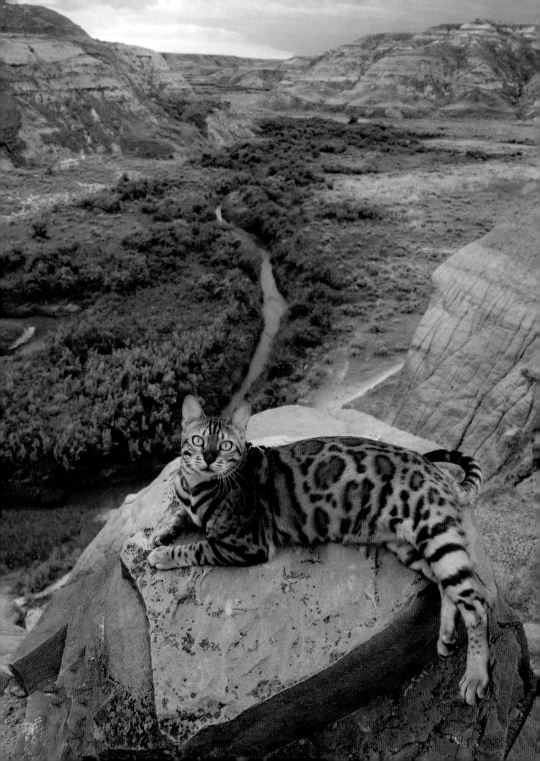

Enjoy the
quiet moments.
It's important
to slow down.

50

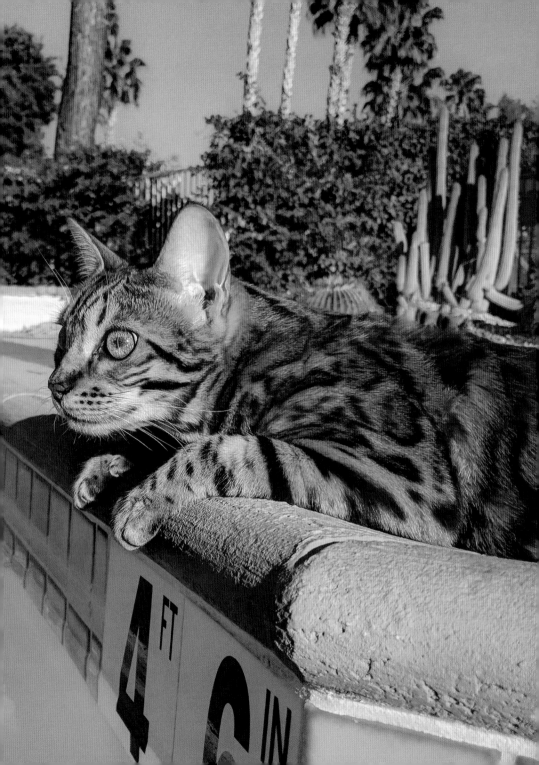

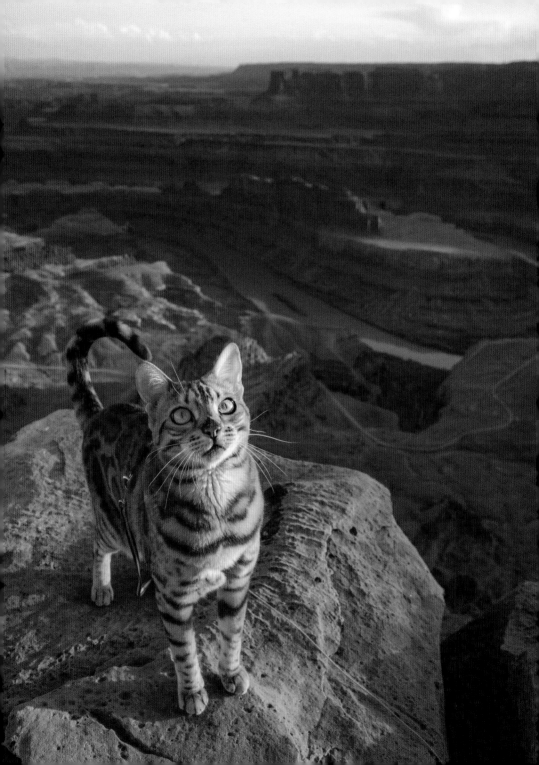

Get out there and live like you have *nine lives.*

SOMETIMES ALL YOU NEED

IS A GOOFY SMILE.

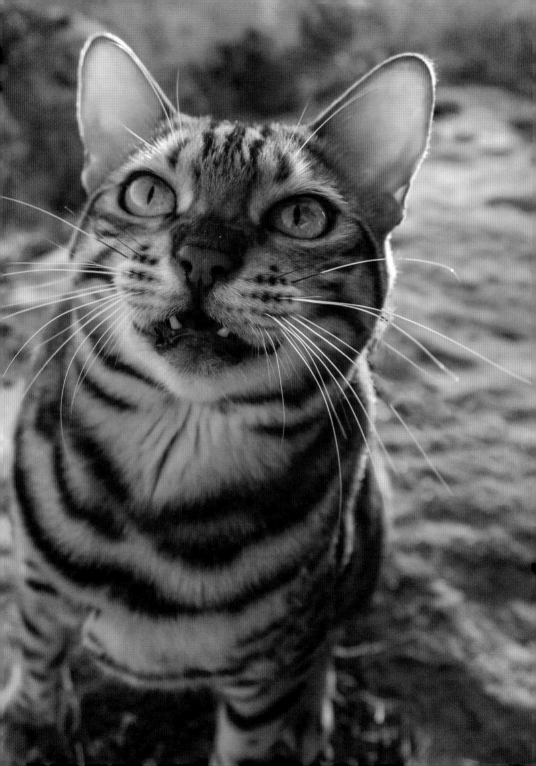

WON'T YOU COME

AND WANDER WITH ME?!

I'm not kitten around here.

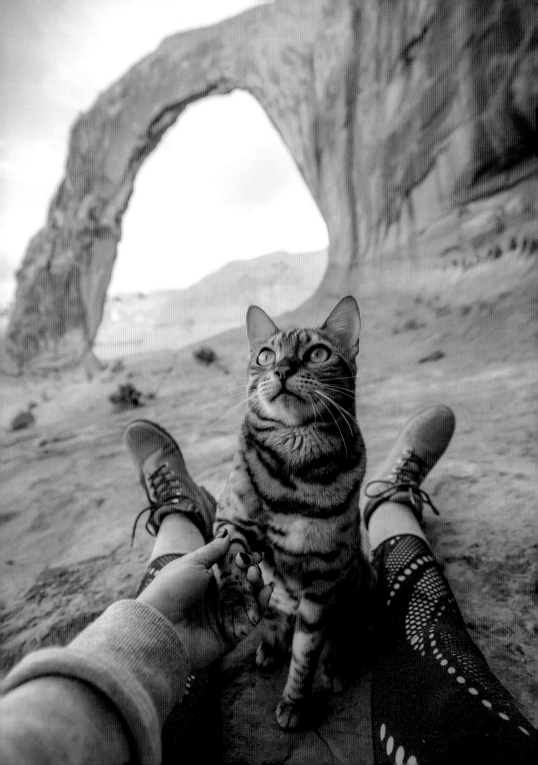

DON'T STOP
NOW WHEN YOU
CAN REACH
FOR THE TOP.

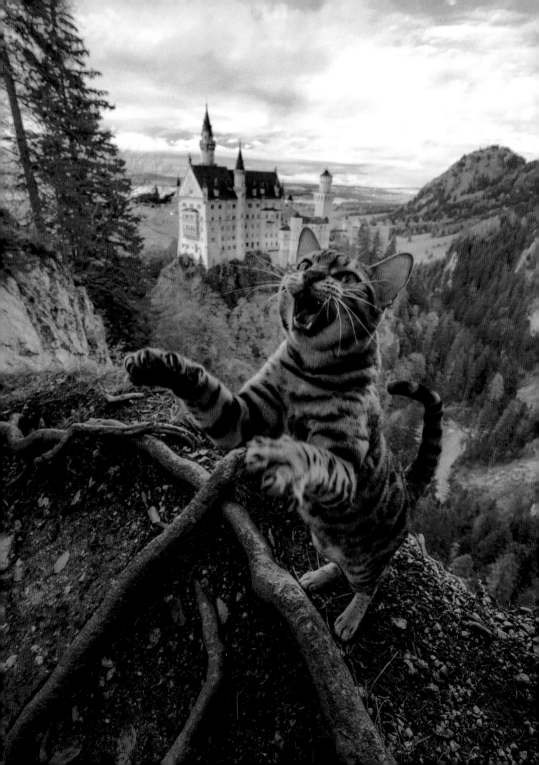

TAKE TIME TO SMELL
THE FOREST AIR.

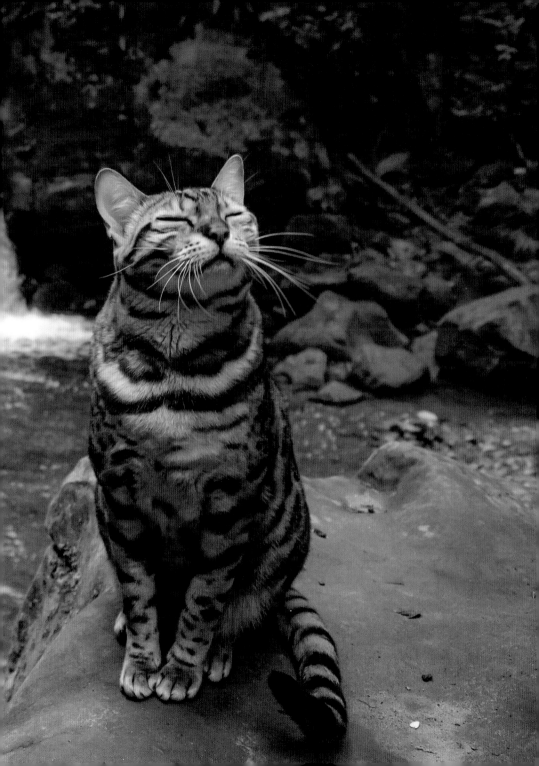

Sometimes the taste of adventure
is just too delicious to bear.

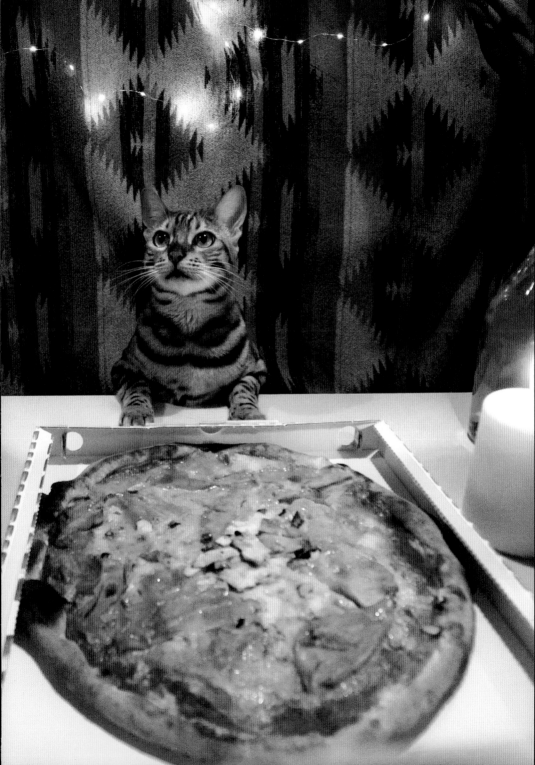

We travel to wild places to
find safety in ourselves.

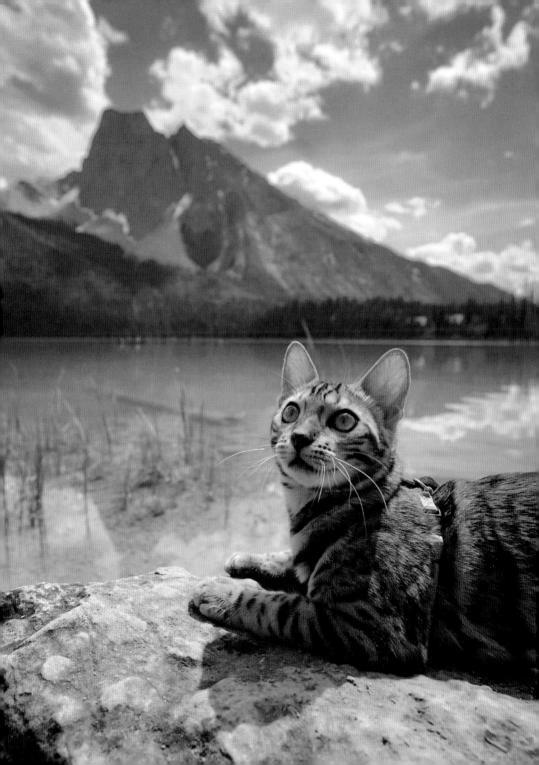

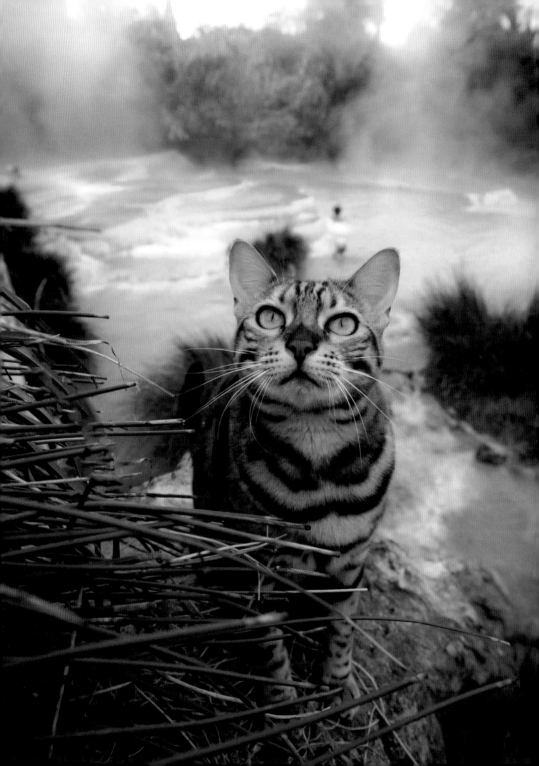

INTO THE UNKNOWN
I GO, TO FACE MY FEARS
AND FIND MY COURAGE.

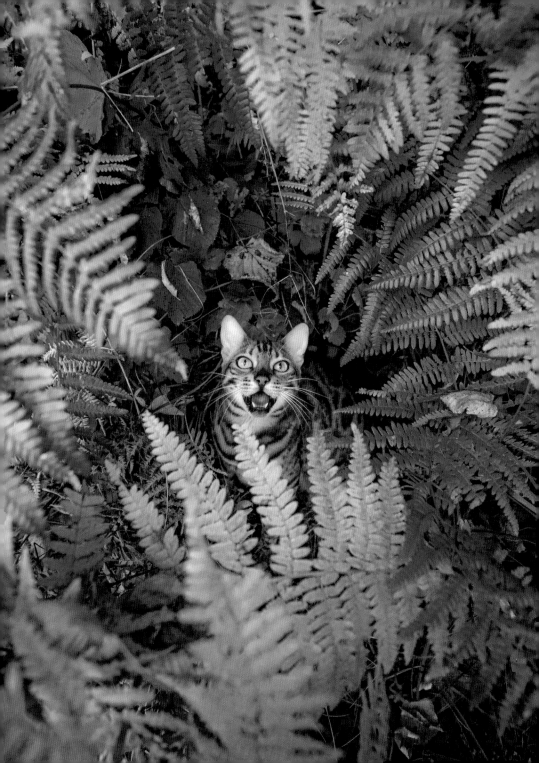

*Curiosity definitely
caught this cat!*

LIVE WILD
TO FEEL
AT HOME.

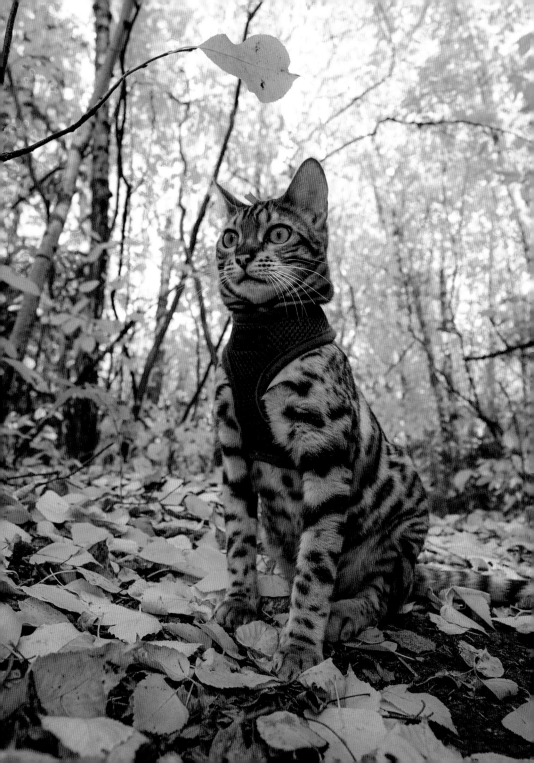

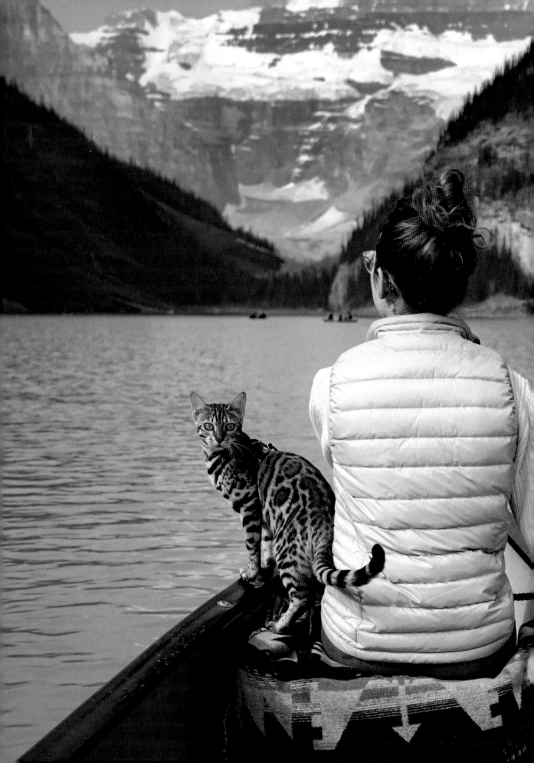

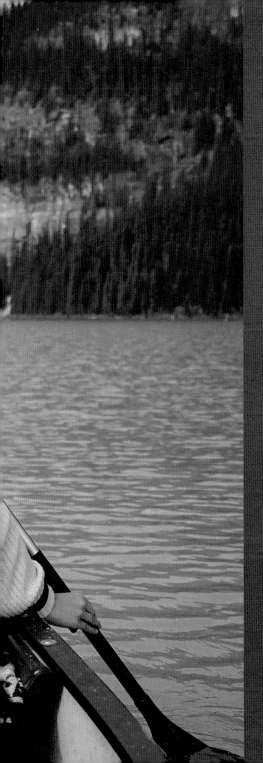

ADVENTURES
ARE BETTER
WITH *you*
BY MY SIDE

73

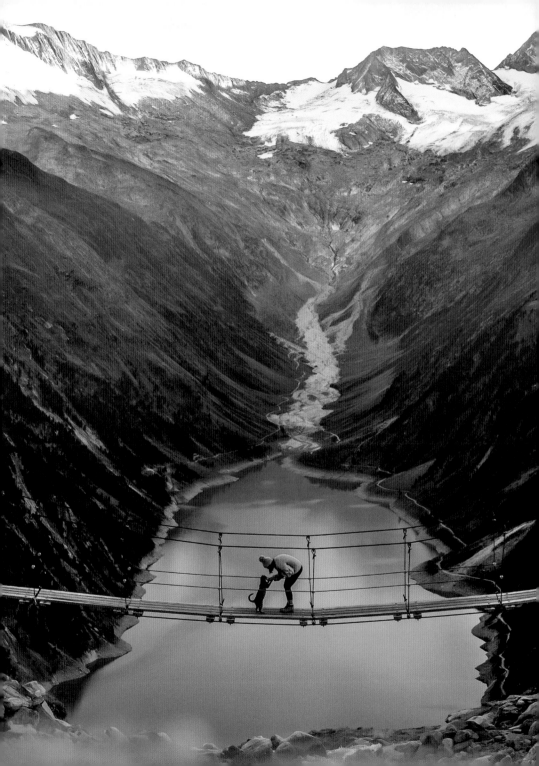

Find balance in the
pursuit of your dreams.

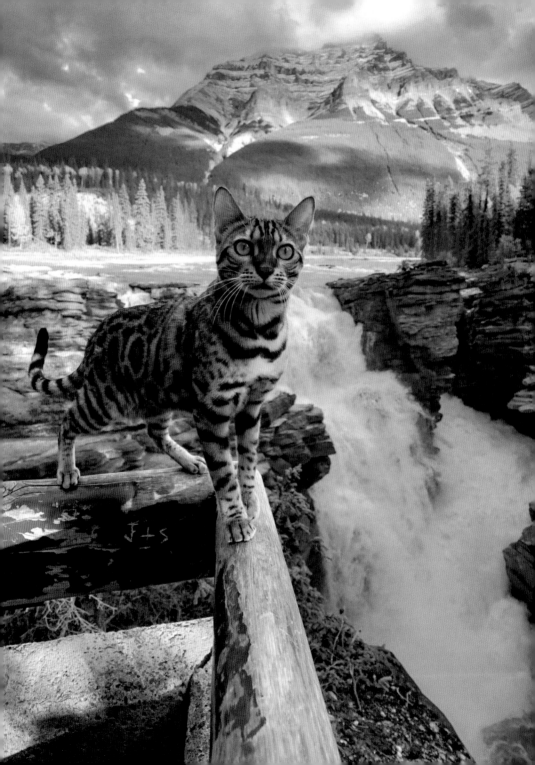

Let the roar of a raging waterfall
remind you of *nature's power.*

THE MOST
EXCITING JOURNEY
IS THE PATH
THAT LIES AHEAD.

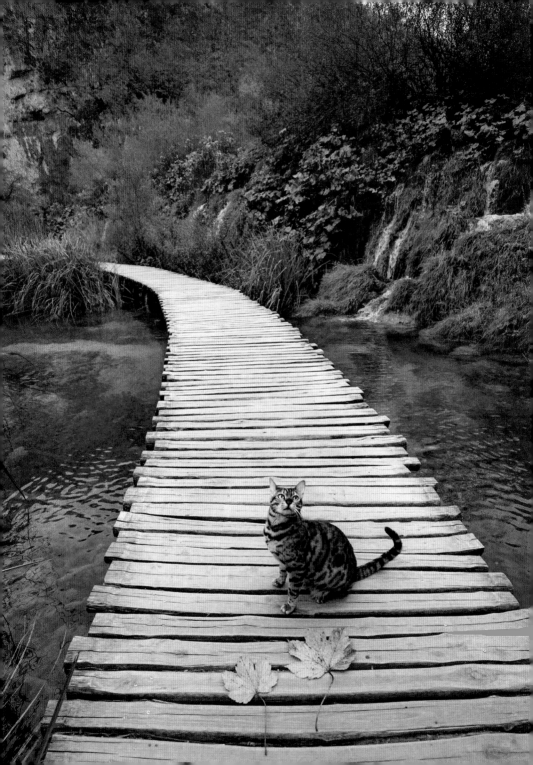

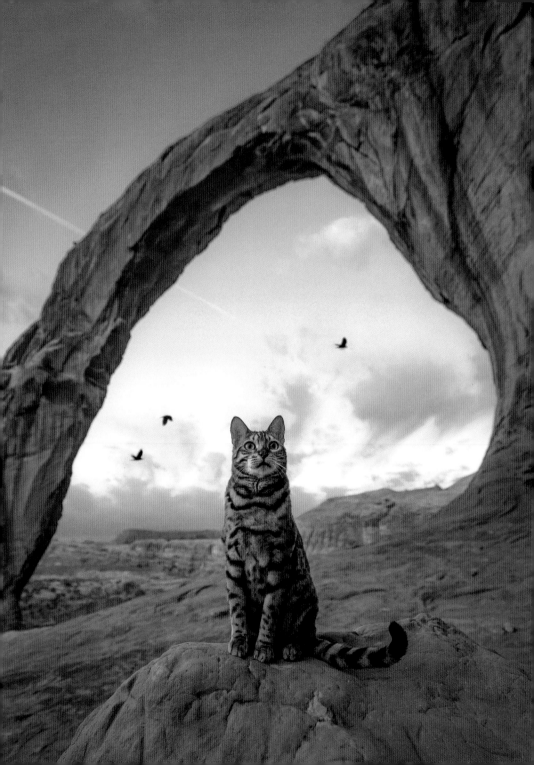

The most meaningful *meow – ments* are when you are deep in unknown lands.

ADVENTURES
SHARED
GIVE MEMORIES
THEIR WORTH.

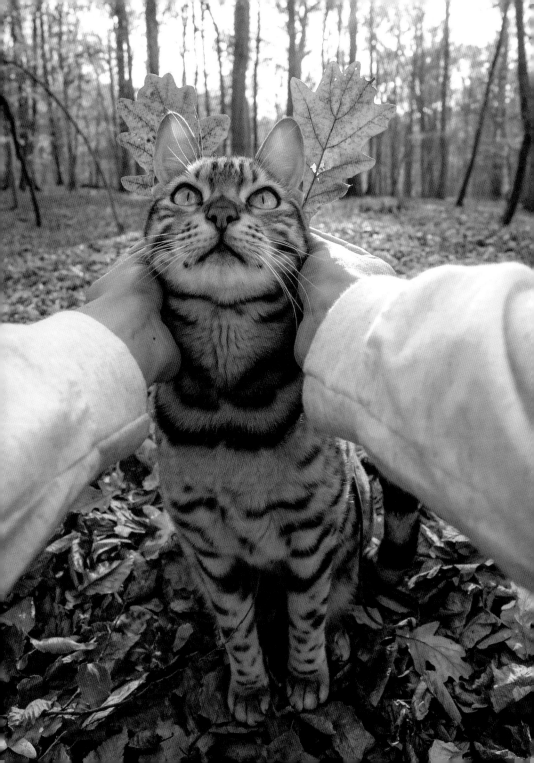

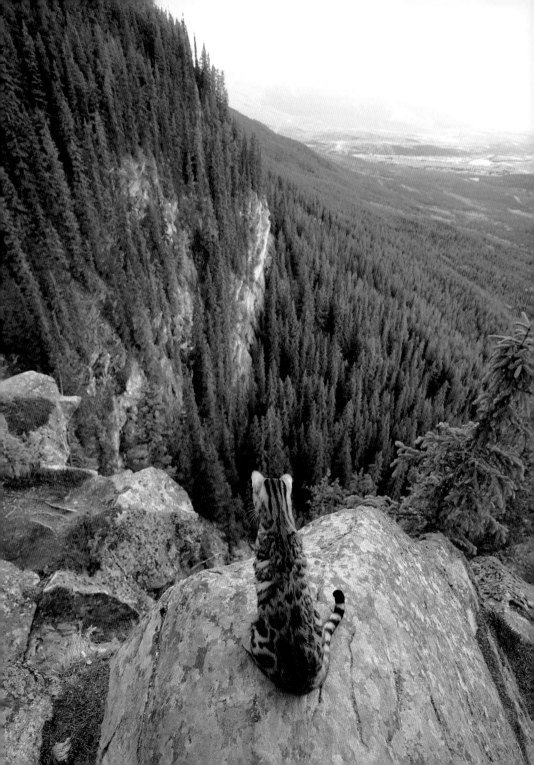

THE VIEW IS BETTER
ON THE EDGE,
DON'T YOU THINK?

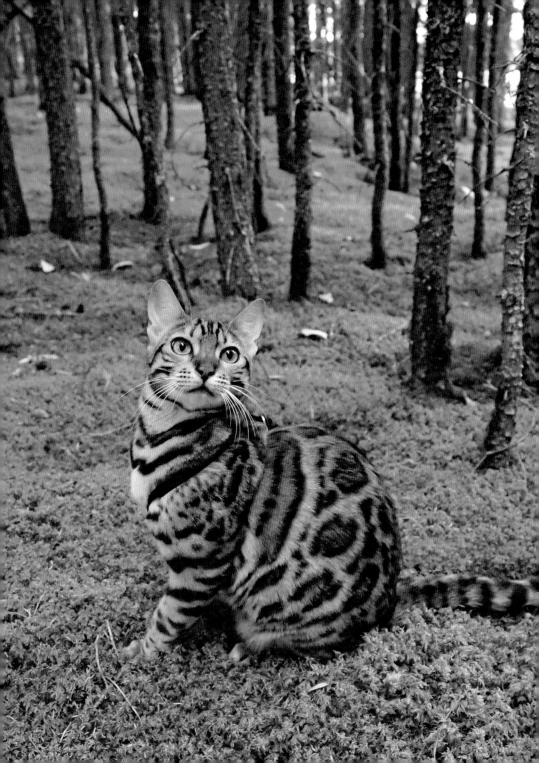

NATURE IS
FULL OF GENTLE
MOMENTS.

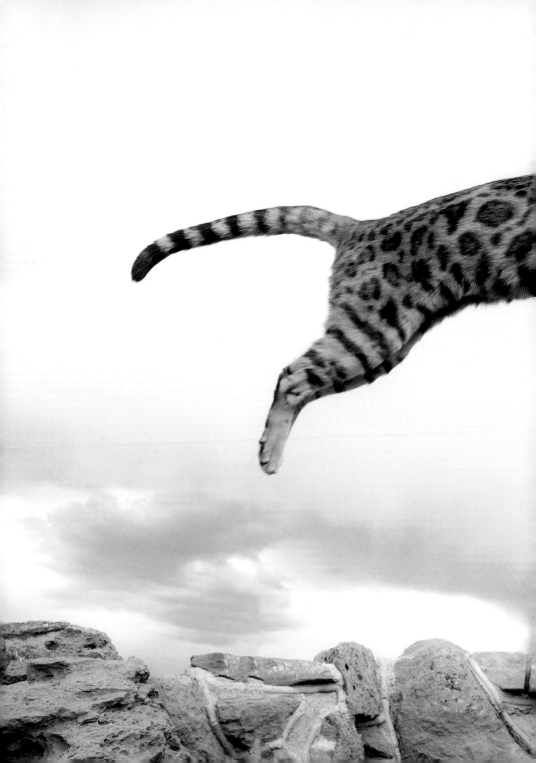

When you take that first leap into the unknown, you must trust the strength of your paws and the strength of your heart.

Don't be afraid to go to the places that scare you. Sometimes it is there where you have the best view.

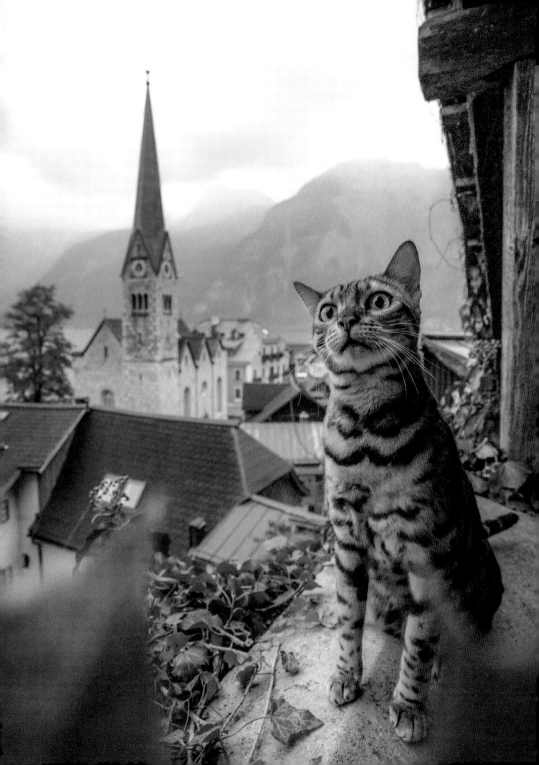

NATURE, TIME, AND ADVENTURE

are natural meow-dicines.

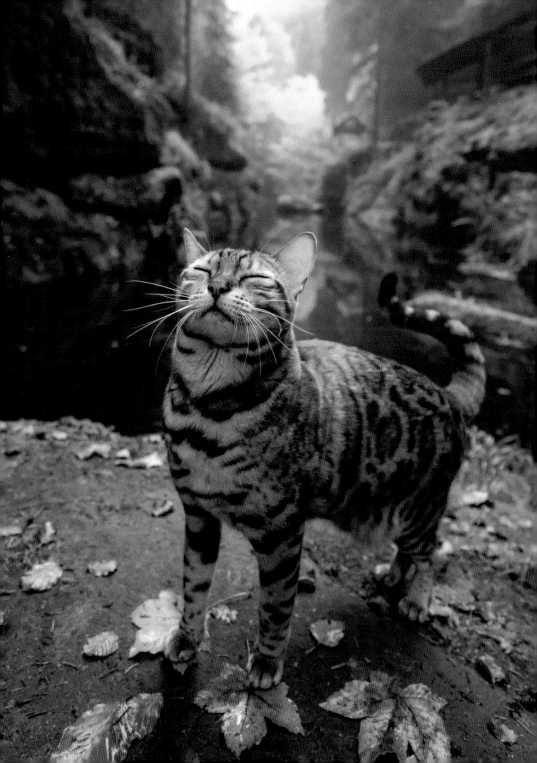

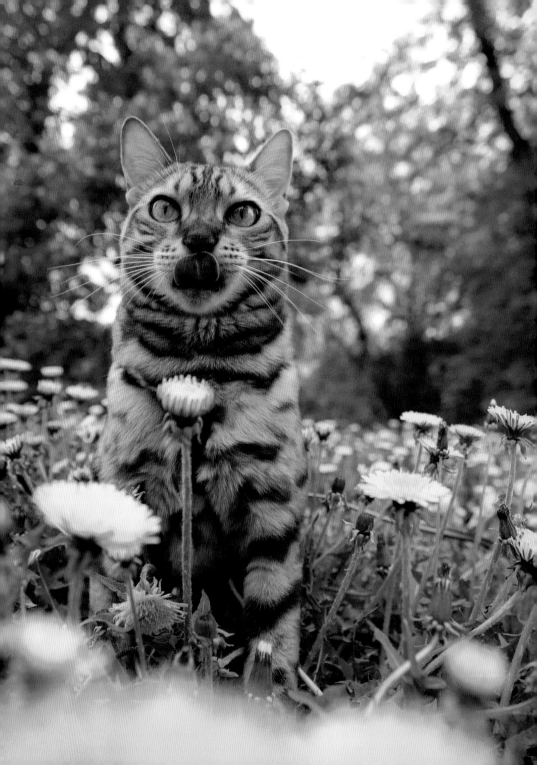

Nothing tastes better than
the taste of freedom.

THOSE WHO
APPRECIATE
THE BEAUTY OF
NATURE WILL
FIND NURTURE
FOR A LIFETIME.

96

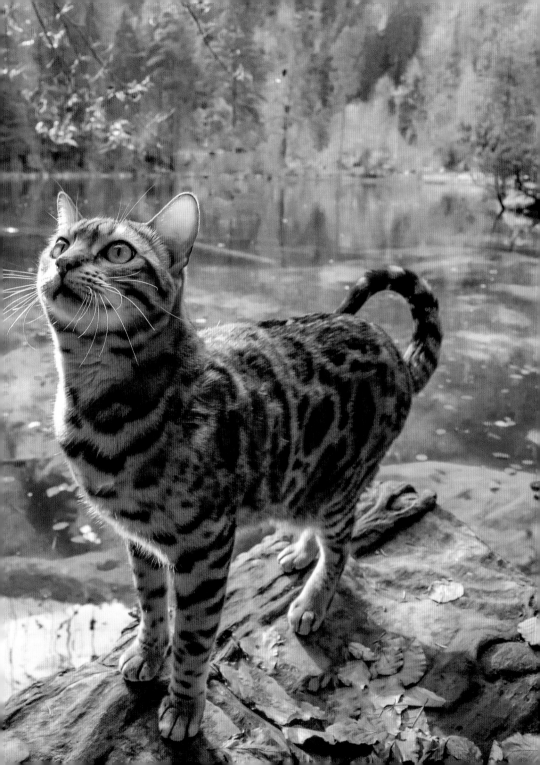

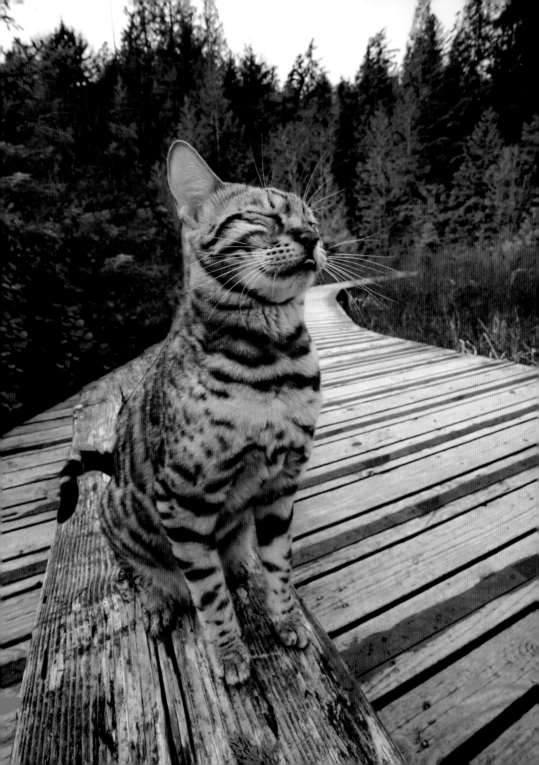

I WAS
SO BOARD
UNTIL
I GOT HERE.

SOMETIMES YOU NEED TO
GET YOUR FEET WET
IN ORDER TO REACH THE SHORE.

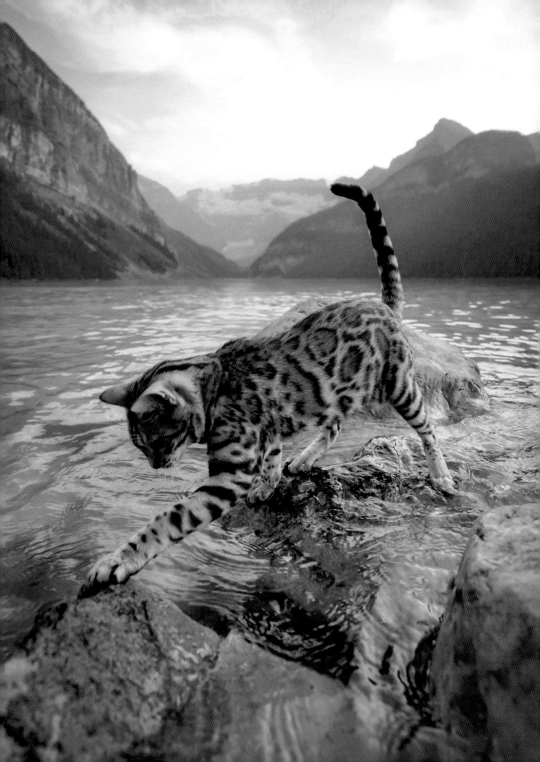

Life can either be a bold adventure
or a snooze in the house.
One smells like litter.

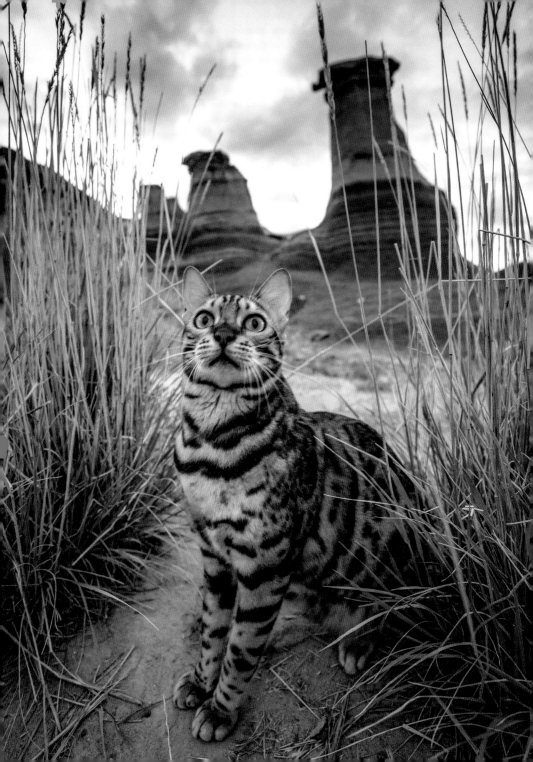

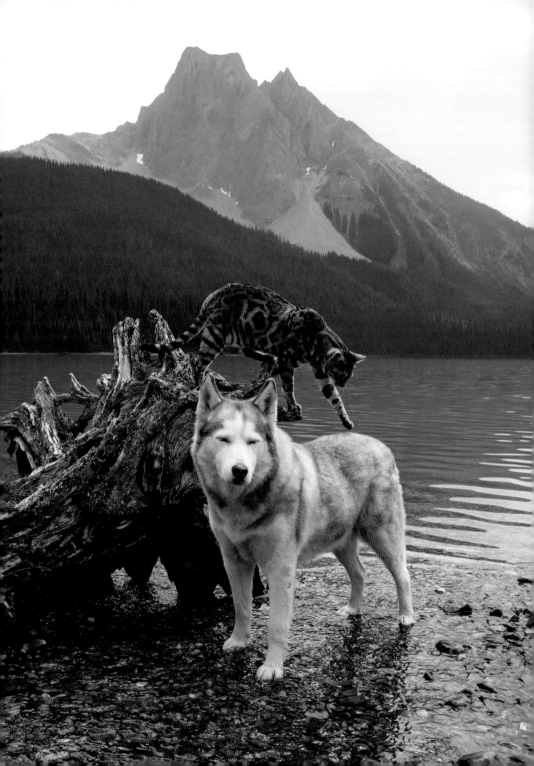

A good
adventure buddy
is the one who always
has your back.

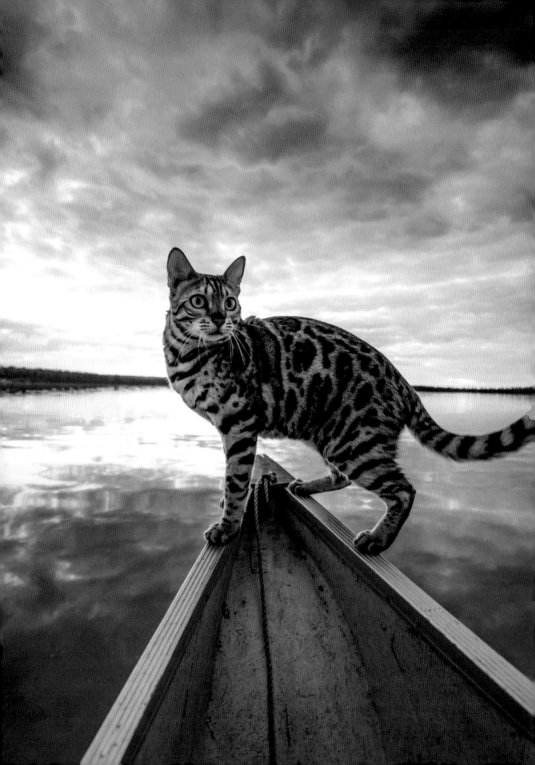

SOME OF THE MOST

purr-fect places

ARE THE ONES I HAVE

NOT YET SEEN.

GETTING OUT
INTO THE WILD
ALLOWS US
TO TRULY BE
REFLECTIVE OF
OURSELVES.

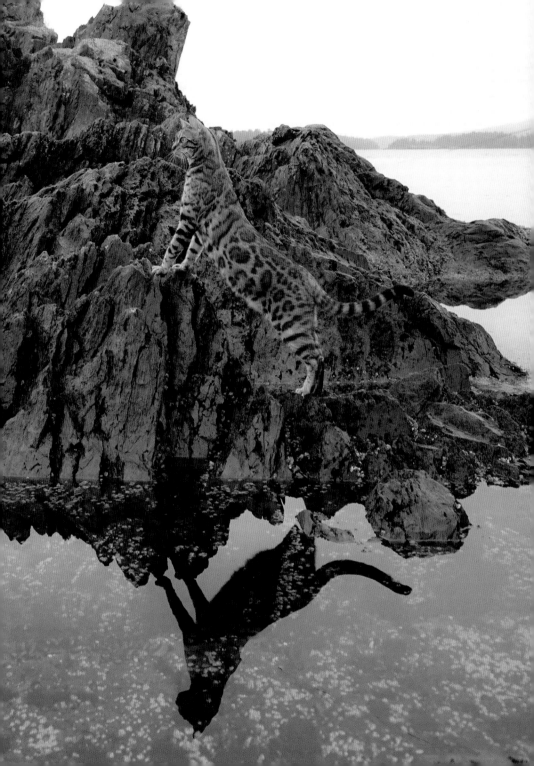

*Let's take
the road less
traveled . . .*

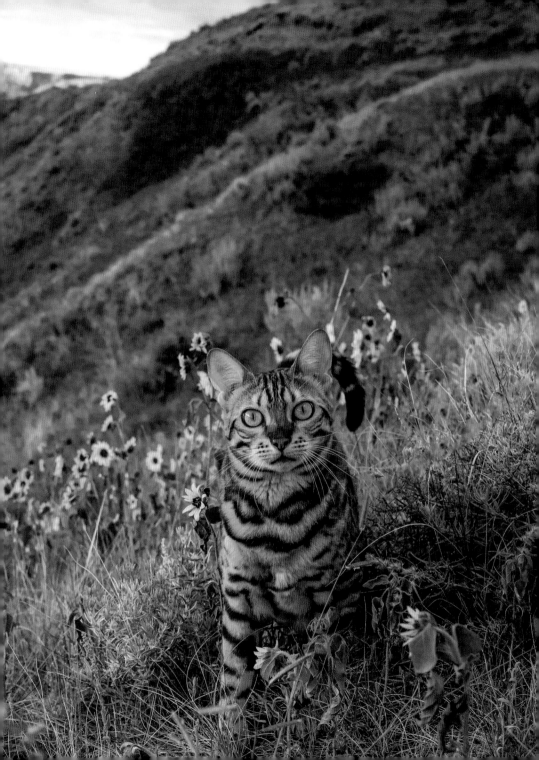

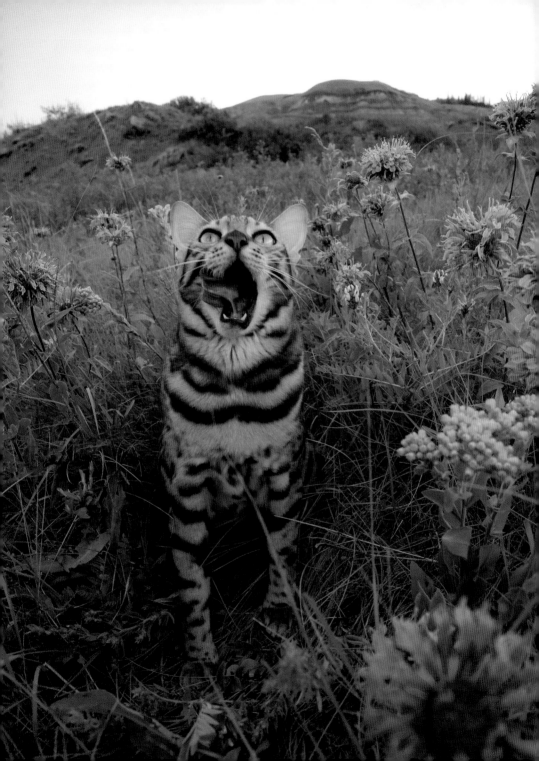

Just like *wildflowers,*
we need *fresh air* and
sunshine to help us bloom.

UNEXPLORED PATHS
ARE A TREASURE TO THOSE
WHO LOVE TO WANDER.

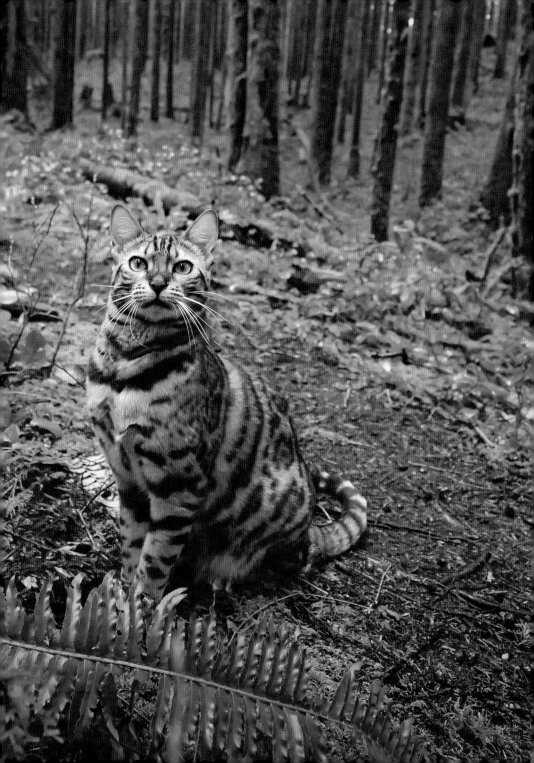

Life is full of peaks and valleys.
If you push on through the challenges
in the valleys, you'll eventually
view them from the summit.

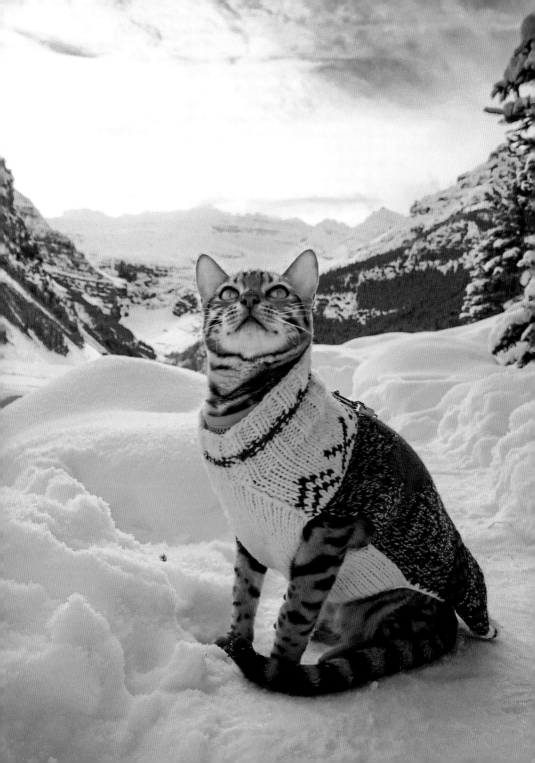

LET YOUR
SUN SHINE
THROUGH
THE SHADE.

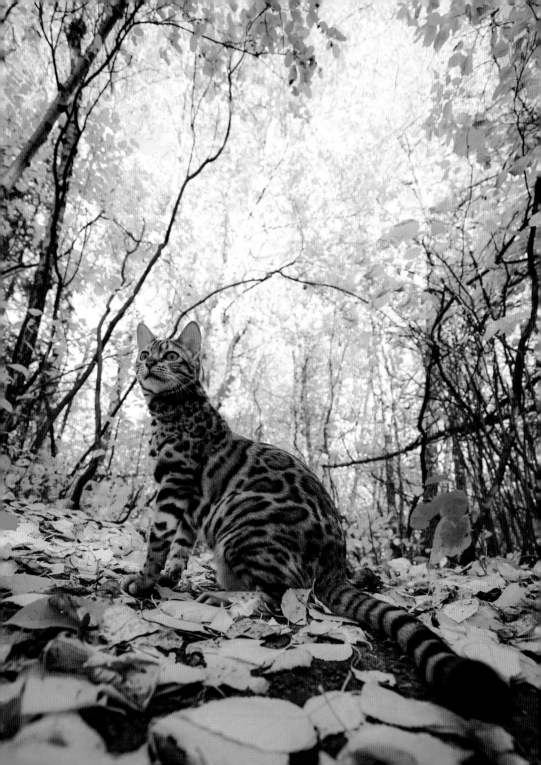

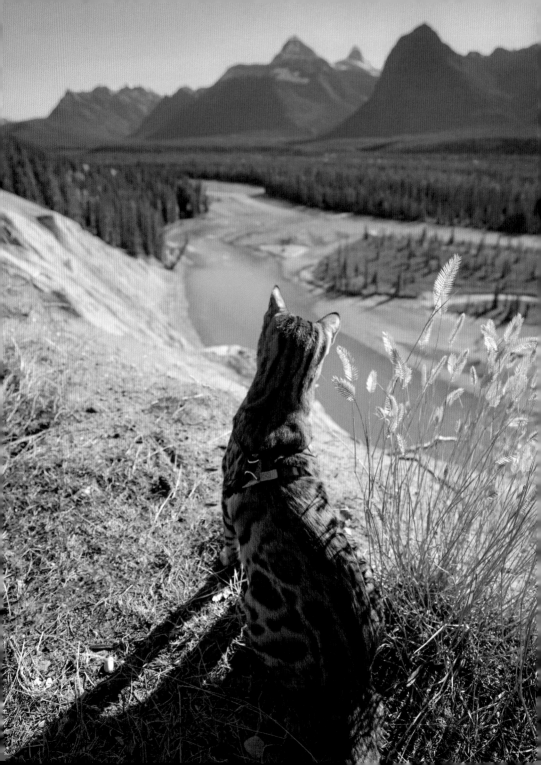

MEOWWWWW,
I've got places to go!

GO
WILD!

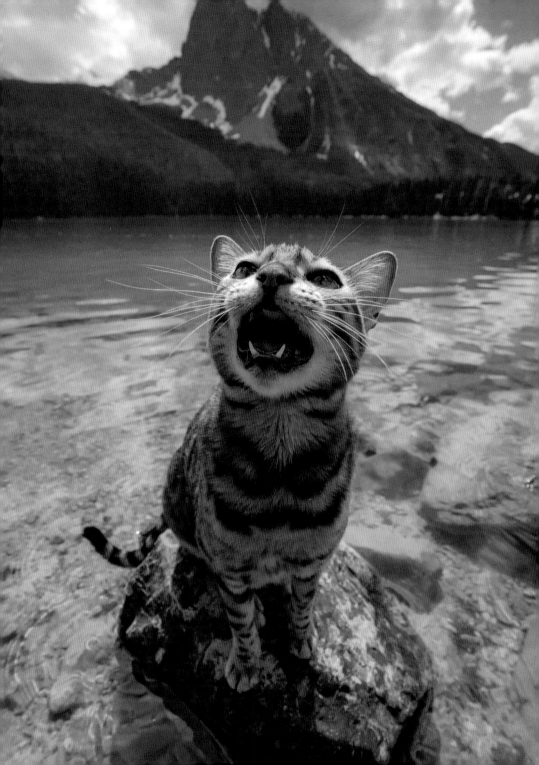

Sometimes you have to stop and look back and see how far you've come to really appreciate how far you can go.

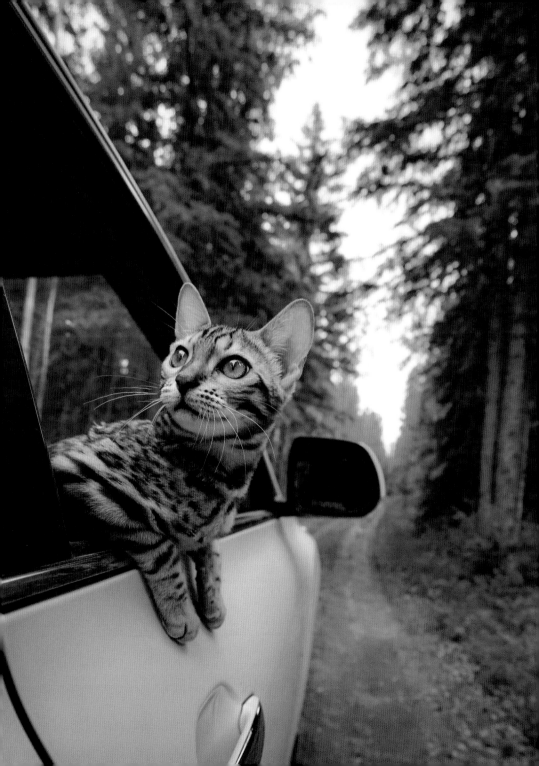

**AUTUMN HAS
TAUGHT ME THAT
THERE IS** *beauty*
IN CHANGE.

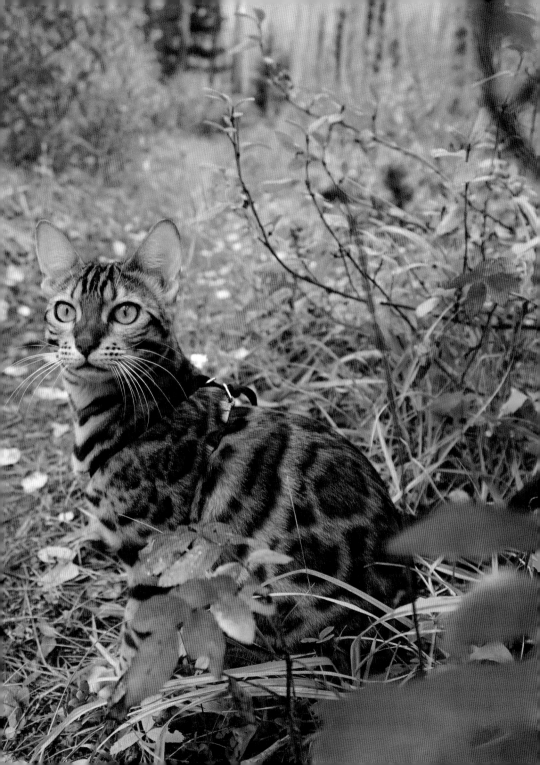

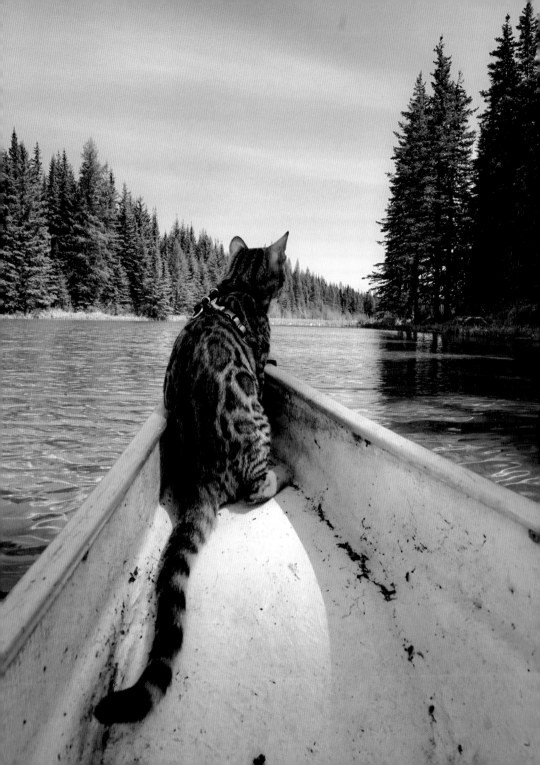

YOU HAVE TO BE IN
FRONT TO BE THE
FIRST ONE TO
REACH THE SHORE.

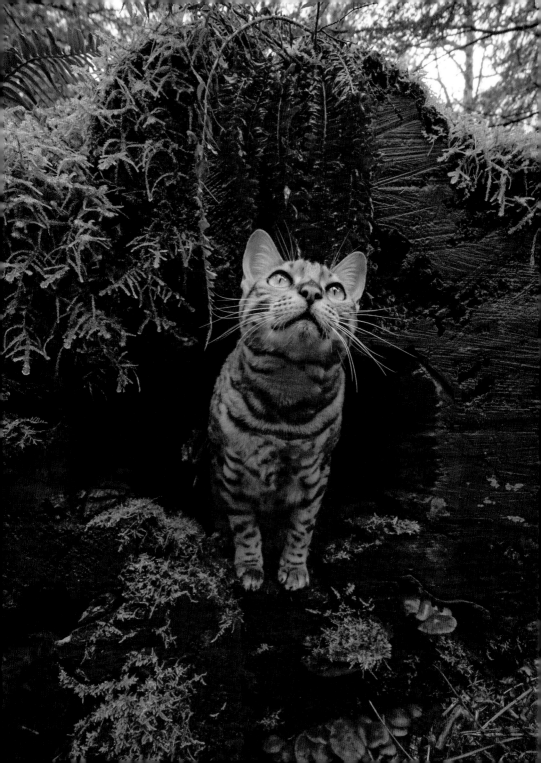

The *purr-fect* place
for peace is in the
depths of the wild.

AS YOU CAN SEE,
THERE IS SO *mushroom*
FOR EXPLORATION!

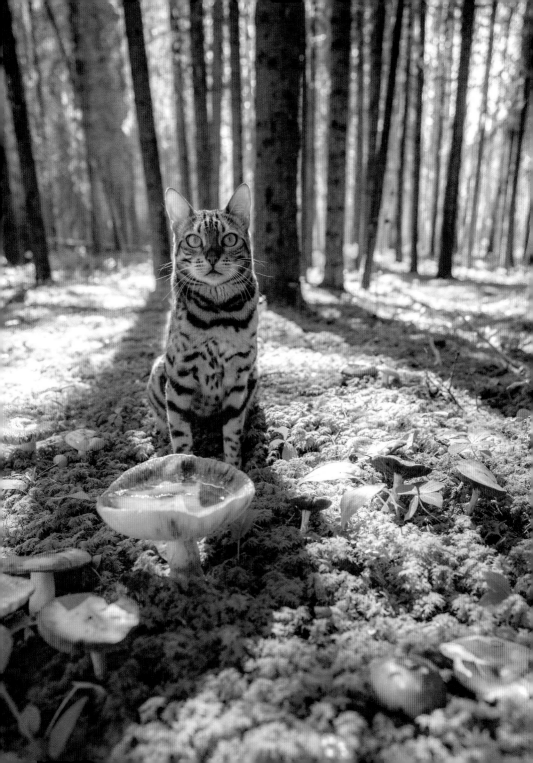

It is better to see
something once
with your own eyes
than read about it
your entire life.

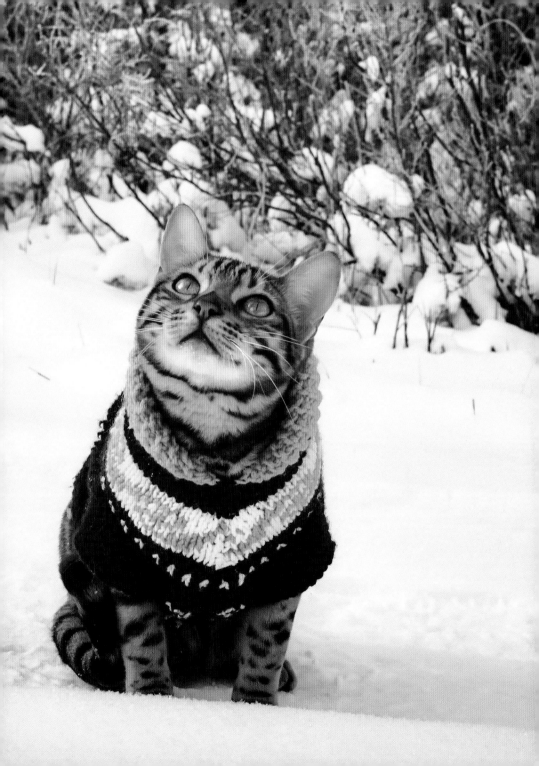

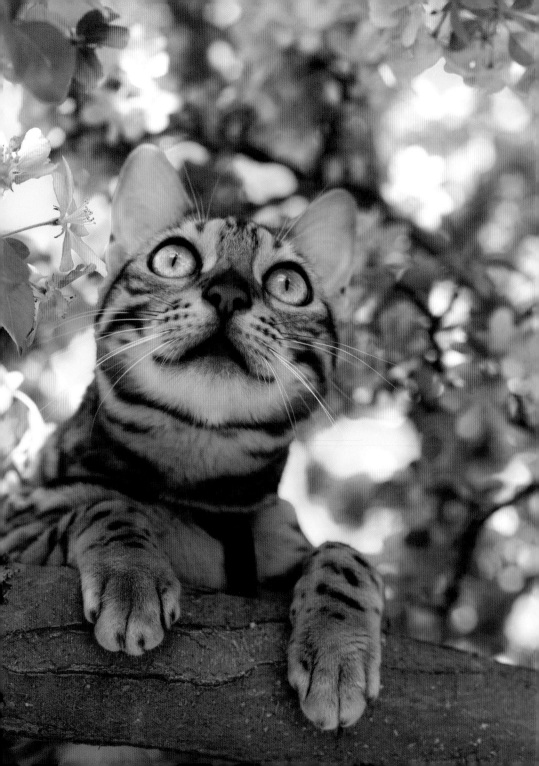

Like a spring blossom,
we open up to those who
illuminate our lives.

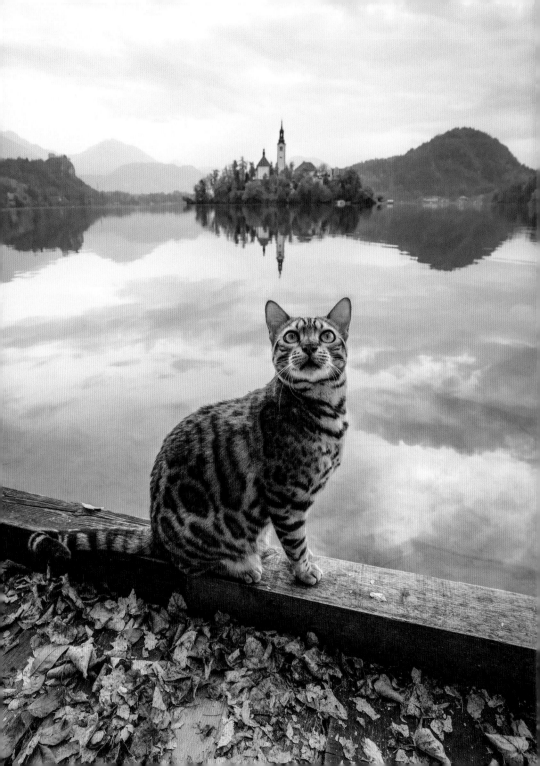

WE BECOME MORE
REFLECTIVE WHEN WE
CALM OUR MINDS.

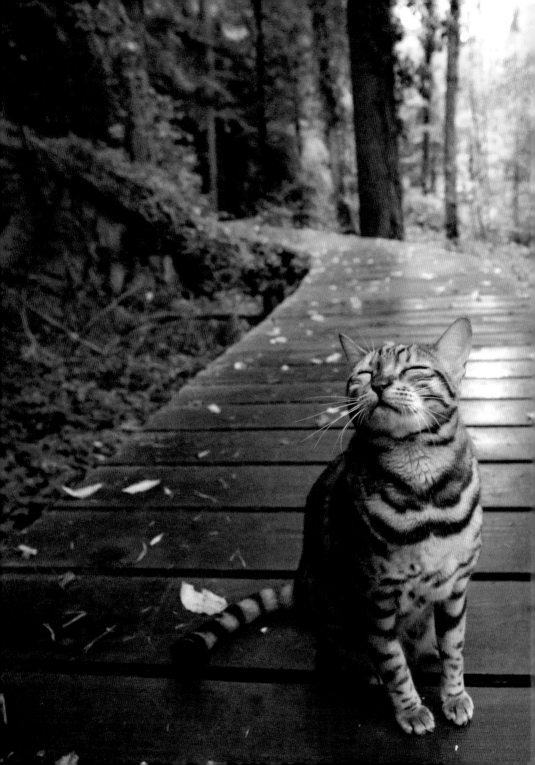

SOMETIMES ALL
YOU NEED ARE
wet paws AND
sharp claws
TO FACE A
SLIPPERY DAY.

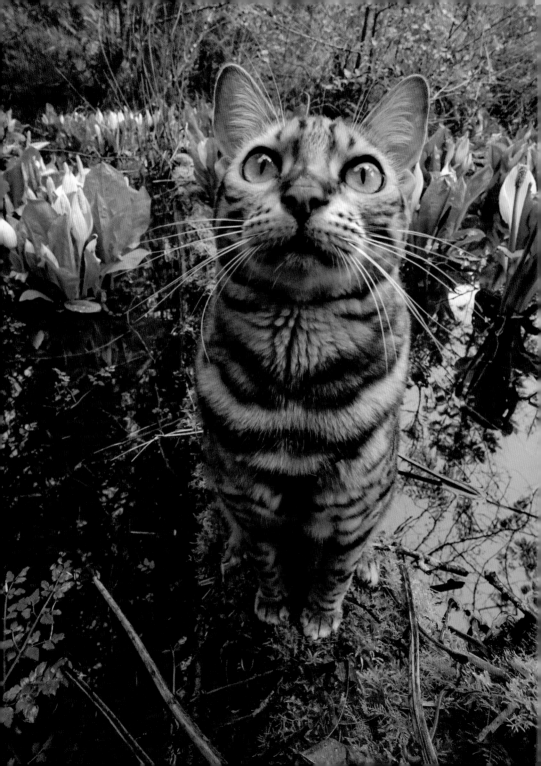

When you become

TOO BIG

for your

LITTLE POND,

it's time to

SWIM AWAY.

THE FARTHER
I TRAVEL, THE
MORE I LEARN
ABOUT MYSELF.

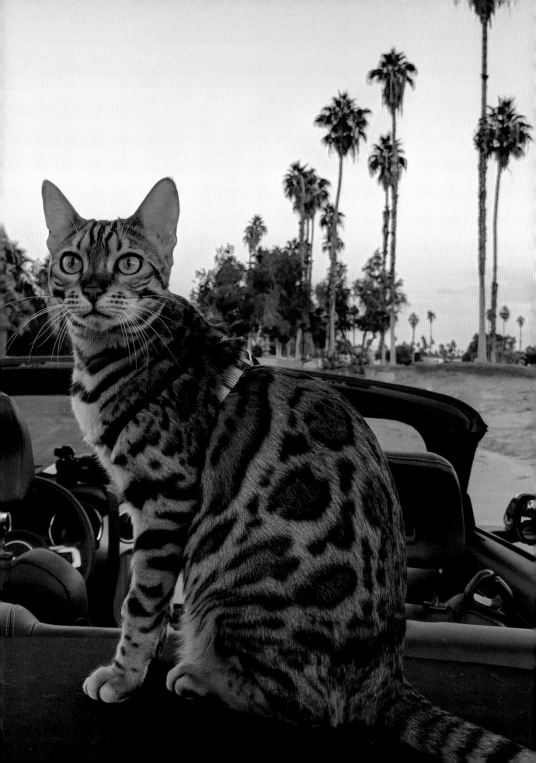

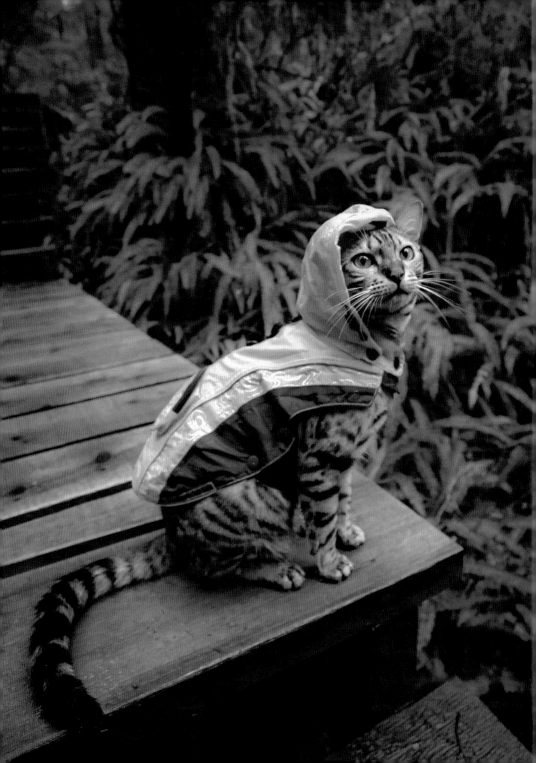

Feel the wet drops on your *nose* and the puddles beneath your *little paws.* This rainy day leaves *no time for sorrows.*

You can shake the snow from your paws,
but you can never shake those memories!

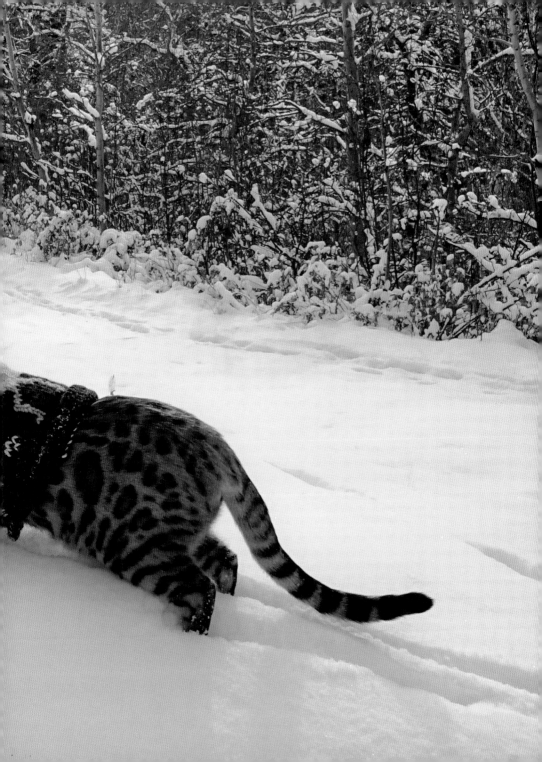

BASK IN THE

SUNSHINE OF

A NEW DAY.

150

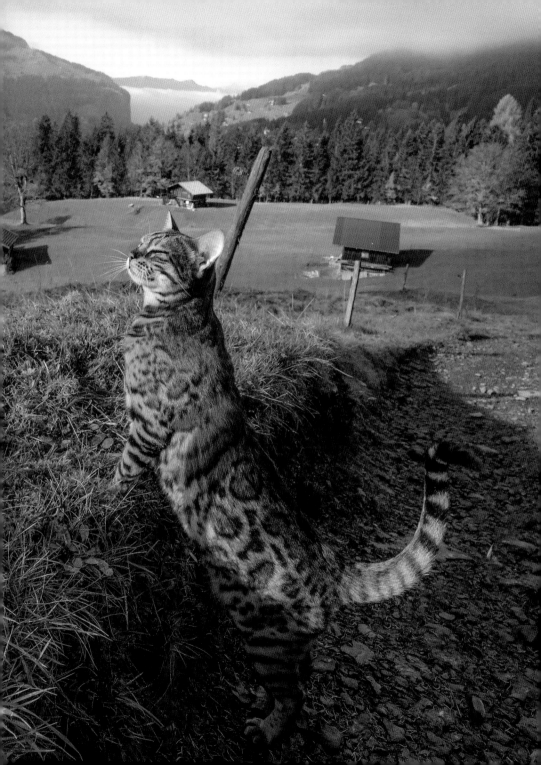

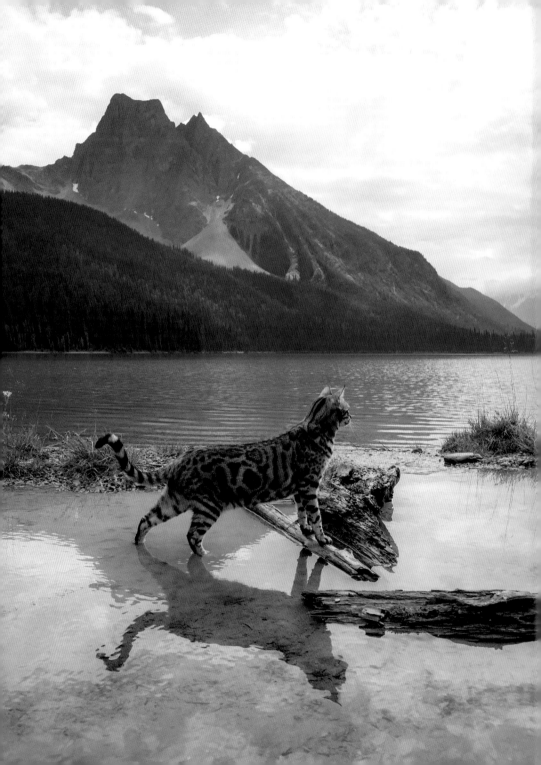

EVEN THE BIGGEST WAVE
BEGAN WITH A TINY RIPPLE,
SO IT'S TIME TO MAKE YOUR
splash on the world!

ABOUT THE AUTHORS

LEIGH-ANNE INGRAM was born in Côte d'Ivoire, West Africa, and now lives with her family and her mischievous cat, Lola (Suki's cat-cousin) by a lovely lake in Ontario, Canada, where she teaches in the Faculty of Education at Lakehead University. Her passion for travel and her curiosity about the world has led her to work, and walk, and dance with people in countries around the globe. Leigh-Anne is an avid lover of cats AND dogs, trees, mountains, lakes, and the natural world.

MARTINA GUTFREUND is a photographer and artist based out of Alberta, Canada. Growing up surrounded by the rugged beauty of the Rocky Mountains has fostered an unstoppable drive for adventure that influences all aspects of her life to this day. Naturally, that yearning for new and exciting experiences has been passed on to her beloved and *ameowzing* cat, Suki. Together, they are on a mission to inspire others to kindle their sense of wonder for all that this world has to offer.

Take a walk, pet a pet, hug a tree.

LOCATIONS

Travels of Suki the Adventure Cat

Andrews McMeel Publishing
a division of Andrews McMeel Universal
1130 Walnut Street, Kansas City, Missouri 64106

www.andrewsmcmeel.com

20 21 22 23 24 TEN 10 9 8 7 6 5 4 3 2 1

ISBN: 978-1-5248-5568-0

Library of Congress Control Number: 2019951736

Editor: Katie Gould
Art Director: Diane Marsh
Production Editor: Elizabeth A. Garcia
Production Manager: Tamara Haus

Photography by Martina Gutfreund

ATTENTION: SCHOOLS AND BUSINESSES
Andrews McMeel books are available at quantity discounts with
bulk purchase for educational, business, or sales promotional use.
For information, please e-mail the Andrews McMeel Publishing
Special Sales Department: specialsales@amuniversal.com.